IMAGES
of America

ALVISO
SAN JOSE

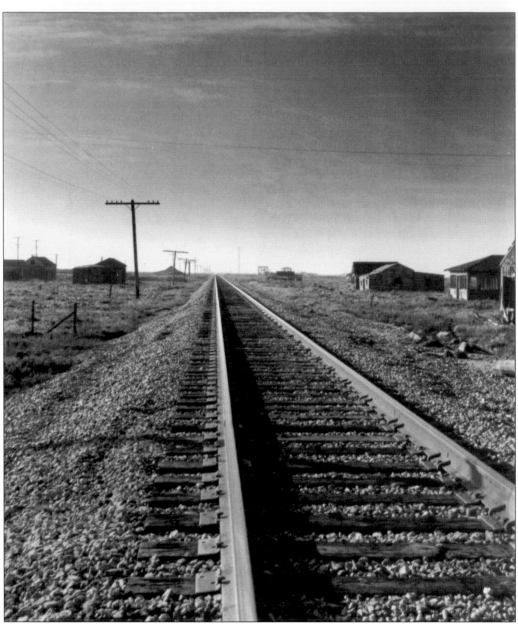

TRACKS FROM DRAWBRIDGE TO ALVISO. The lost port of Alviso lies on the south end of San Francisco Bay, where salt and fresh water meet. It was a whistle stop along the old South Pacific Coast Railroad between the shantytown of Drawbridge and the Lick Mill Spur. The train roared from Alameda to Santa Cruz by way of Alviso on narrow-gauge track laid down between 1876 and 1880. After the 1906 earthquake, the Southern Pacific Railroad widened the track to standard gauge. Alviso is about trains, boats, and seaplanes, a romantic haunt for the free spirit in all of us. Once, Port Alviso was the entrance to the state capital of California; today it is a must-stop along Arcadia's Images of America series of historic places. (DENWR)

ON THE COVER: From 1895 to 1920, the steamer *Alviso* was the pride of the port. (Courtesy Milpitas Historical Society.)

IMAGES
of America
ALVISO
SAN JOSE

Robert Burrill and Lynn Rogers

ARCADIA
PUBLISHING

Published by Arcadia Publishing
Charleston SC, Chicago IL, Portsmouth NH, San Francisco CA

Printed in the United States of America

Library of Congress Catalog Card Number: 2006922941

For all general information contact Arcadia Publishing at:
Telephone 843-853-2070
Fax 843-853-0044
E-mail sales@arcadiapublishing.com
For customer service and orders:
Toll-Free 1-888-313-2665

Visit us on the Internet at www.arcadiapublishing.com

To former librarian Dean Baird, for collecting Alviso's history,
for his clear view of its spirit, and for his courage.

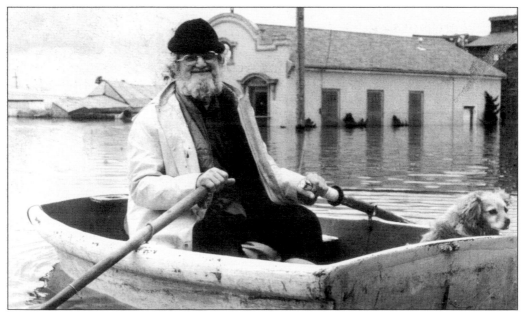

FLOATING ABOVE THE FLOOD, 1983. Alviso poet Ellis Cross rows down Hope Street. An independent, visionary spirit helped Alviso survive its ebbs and flows. From Californios like Ygnacio Alviso, steamboat speculators, Yankee settlers, minority entrepreneurs, women judges, and bracero families, settlers have stayed true to the meaning of the town's name and kept a "clear view." Cross's whimsical poems lift local spirits above the indignities of subsidence, waste, and floods. (Courtesy Emmett Dingle.)

CONTENTS

ACKNOWLEDGMENTS

In 1969, I taught photography and lived along the Alviso-Milpitas Road. The rural land refreshed me. Alviso's boats and trains thrilled the boy in me and inspired my photography.

Collecting material for Arcadia's Images of America volume, *Milpitas*, I found numerous Alviso references. From Mexican rancho times, Milpitas and Alviso have been intertwined. Soon Amelia Vahl welcomed Velma Valencia and myself to Alviso's landmark restaurant, Vahl's, to research the old port. Frank and Paul Rebozzi, Elva Ruiz, Darlene Smith, and regulars David and Warren Vail offered support. When Tom Laine volunteered his photographs, I knew this book had to become a reality.

With few primary sources, most information came from authors Pat Loomis, David Loring, Paul Phillips, Clyde Arbuckle, Benjamin Gilbert, Arthur Spearman, Russell Skowronek, and Rosemary Lick. Gabriel Ibarra, Jim Reed, Mary Hanel, Phil Holmes, Lisa Christiansen, and Regina Denny contributed additional research, and Bob Chapman and Joe Haddox provided technical support. To any who submitted images or notations that do not appear here, I look forward to future publications.

I thank Lynn Rogers for her excellent writing, energy, and intuitive balance—her respect for equality and truth are unequaled. She made some significant finds, including Bo Jangles the cat, who likes everything I write.

—Robert Burrill

Work on this project with Robert was intuitive, involving meaningful coincidences that led us to complement each other's areas of expertise. Though we were both brought up in Menlo Park, California, Robert was ahead of me in school. He and his twin brother were athletes; I marched for peace and civil rights. Our paths didn't cross again until Robert was collecting Alviso images. By this time, I had lived in San Jose for years, written books, and helped students capture memories of the Valley of Heart's Delight.

I am grateful to Robert for the opportunity to join the project as writer, to Joseph Haddox for formatting, Clare Alves for research, Patty Watkins and Bob Keely for support, Megan Flautt for hours of editing inspiration, Fred Huxham for elegant photographs, and to my children's great, great grandmother—one of Alviso's dauntless schoolteachers. She touches my life from beyond. We both have a "special" daughter—along with our accomplished offspring. Grandma Ridley's example inspired me to stick by my child and keep her with me, as she did her own—against all odds.

—Lynn Rogers

Photographs from frequently used sources are acknowledged throughout the book as follows:

(RB)	(Courtesy Robert Burrill.)
(FH)	(Courtesy Fred Huxham.)
(SBYC)	(Courtesy South Bay Yacht Club.)
(TL)	(Courtesy Tom Laine.)
(DENWR)	(Courtesy Don Edwards National Wildlife Refuge.)

INTRODUCTION

Today Alviso is a timeless sanctuary, but once it was a flourishing port. From an Ohlone estuary and sea of mustard grass, it became a mission dock, a busy shipping port, then a train stop, to the sunken town of Drawbridge. Now it lies quietly beside a great wildlife preserve. How did the lost port of Alviso recede into its marshy slumber today? This book traces its ebbs and flows.

Alviso's watery saga begins along the south shore of the San Francisco Bay. For 10,000 years, indigenous hunter-gatherers lived around the seasons. Eighteenth-century Spaniards established California missions and colonized these "coast people." In 1776, fearing English and Russian incursions, Spain sent a colonizing party under De Anza into Alta California. Among the colonists were members of Ygnacio Alviso's family. The first Bay Area missions were named after 12th-century saints Franchesco and Clara de Asis, who, like coastal Ohlone, lived simply and honored nature.

But at the hands of the missionaries, Ohlone perished in large numbers from Old World diseases, violence from soldiers, and disruption of their way of life. Ohlone, who used every part of wild animals, saw Spaniards slay cattle for hides and tallow, leaving the rest for buzzards. When missions secularized, many native people retreated to the hills.

Ygnacio Alviso became chief steward of Mission Santa Clara and was later granted Rancho Esteros. The mission's boat landing, formed on the Guadalupe River, was first called Embarcadero de Santa Clara and later became Alviso. Exports of produce, tallow, and hide expanded to quicksilver from the mines at New Almaden, needed for processing gold and making munitions.

After Mexican independence, some in Washington, D.C. wanted the entire continent from east to west. The Mexican War yielded Texas, New Mexico, and California. Pueblos and missions gave way to merchants like James Lick. Grain from the Santa Clara Valley and Los Gatos lumber supplied a new state, formed around the gold rush.

Alviso was the last stop on the steamboat line from San Francisco and the port entrance to San Jose, which, for a short time, was the state capital. Founded in 1845 and incorporated in 1852, Alviso was later touted by promoters as the "new Chicago of the far West." California's governor built his home in Alviso, and major city plans were drawn. Yet when the railroad roared in from San Francisco on its way to San Jose in 1864, it bypassed Alviso. In 1870, a second railroad split the town down the center, and its landmarks lie on that corridor. But already, Alviso had lost its strategic importance as a port.

Nonetheless, in 1888, the South Bay Yachting Association was established. Recreational boating became vogue, attracting Jack and Charmian London and other notables. But in the early 1900s, this Venice of America began to sink. The culprit was groundwater pumping by zealous farmers throughout the Santa Clara Valley, once known as the Valley of Heart's Delight. While spring orchard blossoms blanketed the valley in white, fruit cannery scraps in the slough sometimes turned the waters black.

Alviso was a doorway for many ethnic groups. Thomas Foon Chew's Bayside Cannery became the third largest in the country. Chinese and Japanese farmworkers earned half of their crops—a unique share in that day. The hardworking Portuguese, the dairy-farming Swiss and Italians, the dust bowl refugees from Arkansas and Oklahoma, the Filipinos, and later the Mexican braceros all came through Alviso and established their families and businesses. Women also enjoyed leadership roles in Alviso. The Baccagalupi and Hollister/Huxham families, for example, gave Alviso father-and-daughter postmasters and judges, and Yolanda Laine was a longtime city treasurer.

With the death of Thomas Foon Chew and the onset of the Great Depression, Alviso's fortunes ebbed. Alviso contended with fights at the Filipino dance halls, Chinese Tong wars, gambling, and prostitution; it was a wide-open town full of schemers and dreamers, gusto and chutzpah. Even the

rabbis made their Passover prune brandy there. Alviso's shadow side also attracted offbeat artistic types who wanted to escape urban life. Knights of the Road and houseboat dwellers drifted into Alviso, some hiding out at Drawbridge.

Vahl's Restaurant opened in 1941—a homey Italian place with five-course dinners and a tough, independent woman at the helm. In World War II, Alviso distinguished itself by building parts for Liberty ships.

Despite these attractions, Alviso struggled with its ambiance. Since the 1870s, San Jose had run raw sewage toward the bay, later into Artesian Slough. Salt farms stopped natural drainage. It stank to high heaven. The problem was finally contained with the lovely new Santa Clara County Water Pollution Control Plant. That remedy led to San Jose's controversial annexation of Alviso in 1974. Real hope rose for Alviso, and the birds of the western hemisphere with the Don Edwards Nature Preservation bill, begun in 1968. This preserve is helping cleanse the bay and protect creatures of land, sea, and air.

Alviso also offers sanctuary for those who want out of the Bay Area's suburban sprawl. It is a district progress forgot, a sinking Atlantis; a Camelot, receding into the mists of California's history. From the planned deepwater port and channel to San Jose, to Henry Kaiser's flying boats that never lifted aloft, Alviso's commerce did not manifest. It was beset with wastes of various sorts, shunted its way by big urban neighbors. Yet because it did not overdevelop, it is not paved over with fast-food restaurants, car dealers, and McMansions. Alviso's unique beauty and independent spirit have survived. Visitors walking the marshes today may sense Ohlone wisdom and St. Clare's mission of simplicity, refreshing their spirits like the estuary wind.

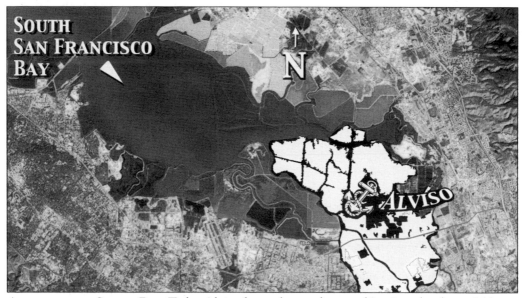

ALVISO ON THE SOUTH BAY. Today Alviso forms the north part of San Jose, bordering Milpitas to the east, Santa Clara to the southwest, and Mountain View to the west. San Francisco lies 42 miles northwest and Oakland 40 miles to the north. (RB)

One

CALIFORNIA DREAMING

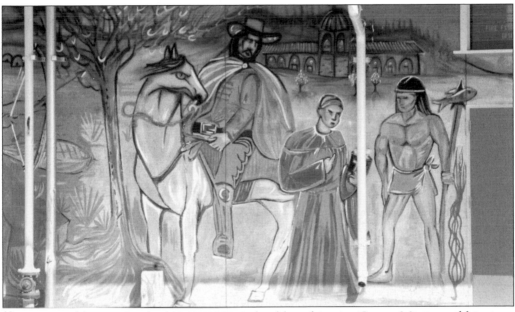

CALIFORNIO MURAL AT ALVISO SCHOOL. School board trustee George Mayne and his sister Virginia, a teacher, descended from Don Jose Francisco Ortega, General Portola's pathfinder. In 1769, Ortega was the first European to glimpse the bay. Indigenous people used abundant natural resources, migrating seasonally, gathering plants like wild grain and oak acorns. In the south bay estuary, berries, salmon, oysters, and duck abounded. Women shaped tule reeds and willow bark into baskets, utensils, and housing. Fishermen maneuvered tule boats though waterways, called by Ohlone tribal leader Ann Marie Sayers, "the blood of the earth." When Portola chose mission sites in Santa Clara Valley, Franciscan father Crespi saw a great river across an estuary, "filled with marshes, lakes, and creeks." Wielding both cross and sword, the newcomers captured, threatened, and lured the "Clarenos" to the mission. Many died of disease, and others fled. The Mexican governor granted three tracts of land in this region, including Rancho Esteros to Ygnacio Alviso, chief steward of Mission Santa Clara. The mission's embarcadero became a larger port, bringing steamers and trade. When San Jose became the first state capital, speculators discovered the area. Without bridges to span the bay, Alviso became the inner gate to the golden state, center of trade activities for the Santa Clara Valley. (Mural by Rogelio Duarte, 1977. Courtesy George Mayne Elementary School.)

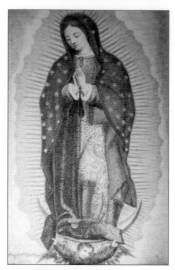

RIVER NAMED AFTER GUADALUPE. On March 30, 1776, with great difficulty, the De Anza expedition crossed a steep river in the south bay. They named it Rio de Nuestra Senora de Guadalupe, who is believed to have appeared to Juan Diego in 1541 on a Mexican hillside. Her image was imprinted on his bark vest, or "telma," and was carried by the Spanish to California. (Courtesy Lynn Rogers.)

THE MEANDERING RIVER, 1940. This aerial view traces the Guadalupe River before it was straightened. Here it flows freely, gently flooding at every oxbow bend. It nourished the valley, forming the stem of its alluvial fan, its lifeline. Now houses cover much of its course, but in this image, a honeycomb of farms and orchards lies along the river, winding its way through Port Alviso. (Courtesy U.S. Geological Survey.)

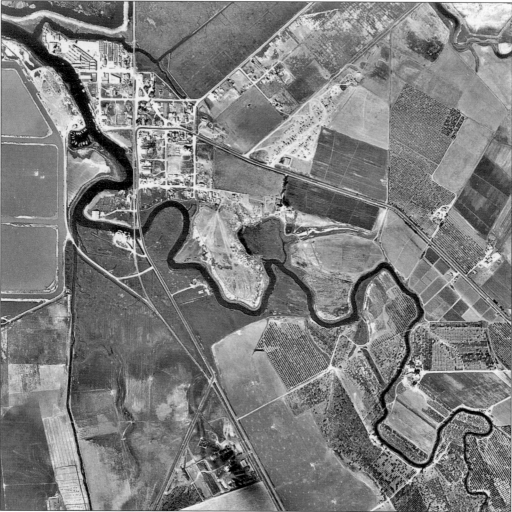

THE ALVISO SLOUGH. Early in the 19th century, Alviso was still a wild, broad marshy plain covered with mustard, unbroken for miles. Wild animals and game held sway. (RB)

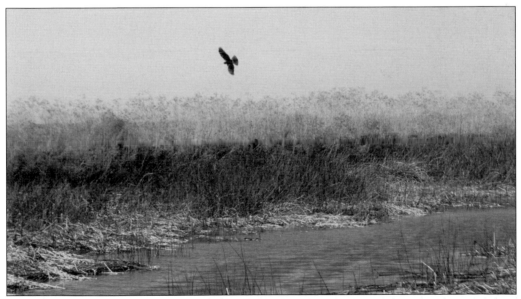

RED-TAILED HAWK. Shorebirds have flown over this area for ages. Alviso has become their refuge, spanning 30,000 acres of open bay, salt pond, salt marsh, mud flat, upland, and vernal pool habitats. Located along the Pacific Flyway, it hosts over 280 species of birds each year, offering sanctuary at the estuary's edge. It will take at least a century to heal the damage of urban waste, dikes, and salt ponds to restore Alviso's early natural balance. (RB)

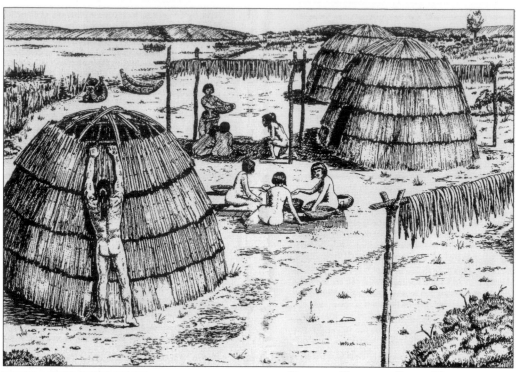

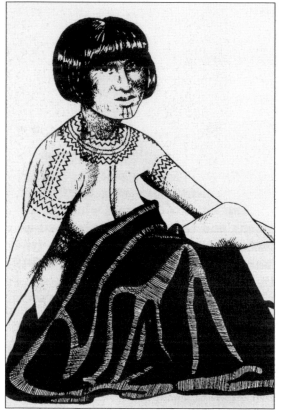

OHLONE VILLAGES BUILT NEAR WATER. Ohlone clothing adapted to the weather. Little clothing was worn in summer—women might wear braided tule grass skirts. In winter, Ohlones wore robes of rabbit, sea otter, or duck feathers, plentiful here. Abalone and Olivella Biplicata were very sacred shells to the coastal people. The same size discs are still used today in dance, burial, and other ceremonial regalia. (Courtesy Daniel Liddell.)

OHLONE WOMAN'S ADORNMENT. Adornment was important in life and in death, as gravesites near Coyote and Penetencia Creeks revealed. Ohlone spirituality balanced "feminine" cyclical, regenerative forces with "masculine" unpredictable elements like rain and war. When the Spaniards came, they imposed Christian leadership, tying it to male Ohlone leaders and masculine images. The feminine center of religion and cultural life was overtaken—but survives today. Most documented medicine people are women. (Courtesy Daniel Liddell.)

THE REGION'S FIRST BOAT BUILDERS.
The Muwekma Ohlone made their home in the estuary region. They slipped through the sloughs in boats made from tule reeds and willow bark. Tule reed boats would last a season and traversed the bay waters for thousands of years. Modern recreations (like the Kon-11 at East Bay Regional Park) show them ideally suited for plying the bay, including sloughs only six inches deep. (RB)

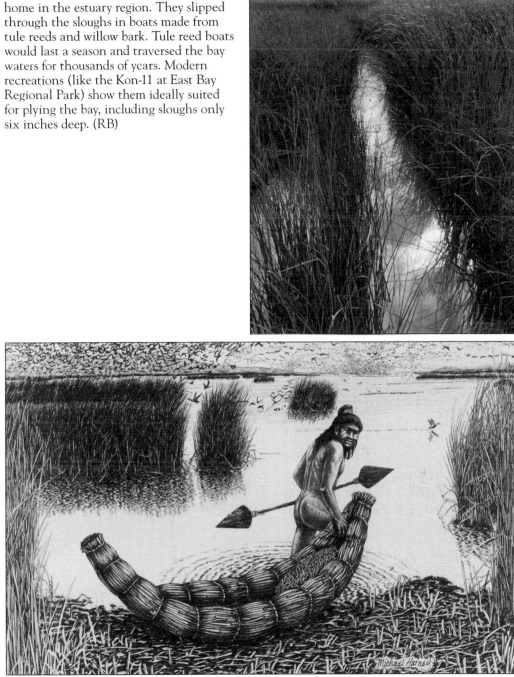

OHLONE BOATMAN. In 1792, Captain Vancouver wrote about American Indians who fished in tule boats "when heavy seas kept European ships at anchor." In 1933, Von Kotzebue noted Indians sitting "up to their hips in water." He did not understand how these coastal people adapted to their environment. This familiar drawing suggests how coastal natives dressed—or undressed—according to the tasks of the seasons. (Courtesy Heyday Books.)

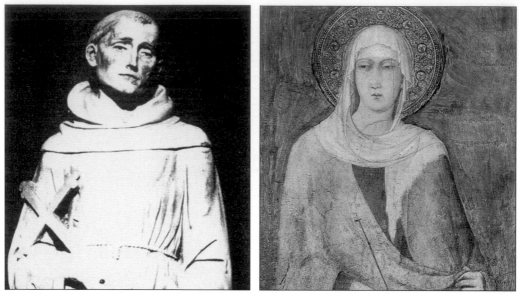

SAN FRANCISCO DE ASIS AND SANTA CLARA DE ASIS. St. Francis called animals and natural entities like the wind brothers and sisters. He and companion St. Clare lived simply and celebrated the Creator in nature, as did the Ohlone. He was considered the medieval manifestation of Christ, with stigmata lesions similar to Christ's wounds. Clare had fled her wealthy home, cut her golden hair, and sold her possessions for the poor. Their "Canticle to the Creatures" was written while she tended his ailing eyes. St. Clare is highly esteemed by Alviso's Hispanic community. The town's earliest name translates to "the dock of St. Clare." Like "Alviso," "Clare" means "clear view." (Courtesy *Franciscan Herald Press* and Lynn Rogers.)

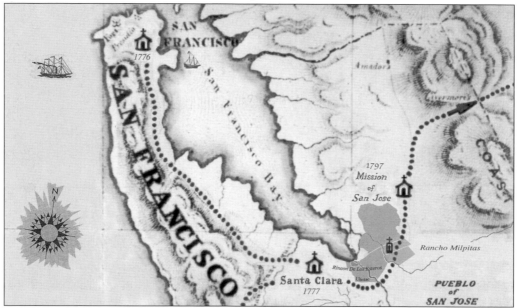

MISSION ROUTES AROUND ALVISO. It was a long day's walk from St. Francis's mission to St. Clare's and another day to Mission San Jose. Without bridges across the bay, the only way to get east was to walk south. During the gold rush, miners used the old mission road. (Courtesy Milpitas Historical Society.)

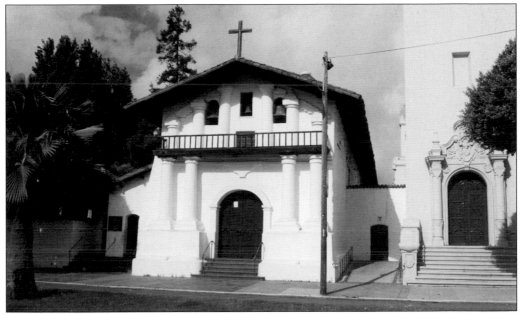

MISSION SAN FRANCISCO DE ASIS. "If St. Francis desires a mission let him show us his harbor then he shall have one," General Galvez challenged Fr. Junipero Serra. Founded in 1776 near Dolores Creek, the sixth mission was named for the founder of Father Serra's order. In 1782, it moved to (today's) Dolores Street. The padres found their Pacifica farms foggy. They scouted south to feed their mission and fulfill the Viceroy's mandate of a second port establishment. (RB)

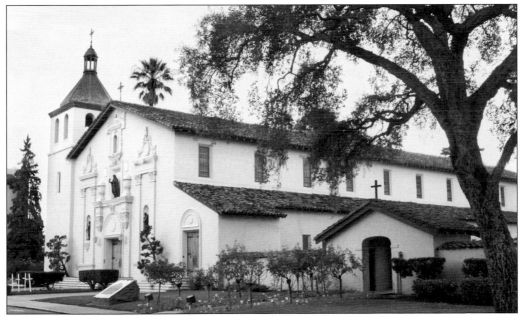

MISSION SANTA CLARA DE ASIS. In 1777, Fr. Junipero Serra founded the second mission on the bay, in sight of Guadalupe River. Made of tule and log, this eighth California mission was the first named after a woman. It provided food for San Francisco via water, and its landing dock became Alviso. Floods moved the mission a musket shot away. After three more moves, it came to today's university grounds, where it was ravaged by earthquake and fire. (RB)

CROSS ON EL CAMINO. This wooden cross was fashioned for the University of Santa Clara by Alviso sculptor Charles Everett. It marks the first Santa Clara site on the old Spanish foot trail connecting 21 missions. Parts of today's U.S. Highway 101 and El Camino Real are the original "King's Highway" or trail, running 650 miles between San Diego and San Rafael. (RB)

THE FIRST SETTLEMENT. Late in 1776, Commandant Rivera and Father Pena traveled from the San Francisco Presidio and found this river "containing a great deal of water," with springs fit to irrigate mission crops. They returned January 12th with soldiers and supplies and planted a cross and arbor as a temporary church. Bayshore Highway, De La Cruz, and Kifer Road now surround this first mission site. Historic Marker No. 250 once marked the spot. (RB)

16

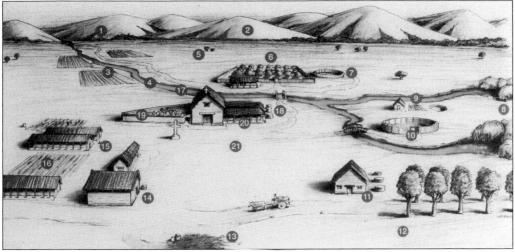

THE FIRST TWO MISSION LOCATIONS. The padres tried for two years to "win the friendship" of the "Clarenos" to develop their mission. In January 1778, Guadalupe River and Mission Creek floods forced the missions to relocate to the west (No. 2). By 1790, herds and crops grew and they needed an embarcadero on the river near the mouth of the bay. A cart path was laid four miles north, bypassing the meandering Guadalupe. (Courtesy Santa Clara University.)

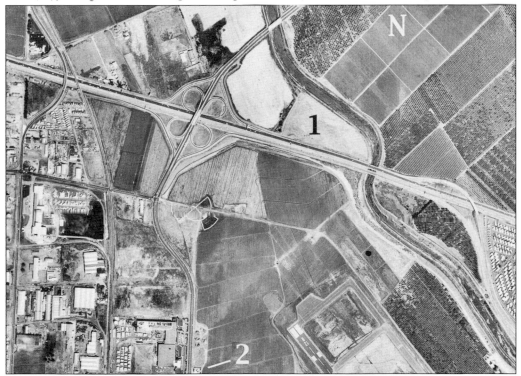

TWO SITES SEEN FROM ABOVE. This 1980s aerial photograph reveals original mission locations. The first settlement (No. 1) was near the old Guadalupe River before it was realigned in the 1960s. This site lies between Highway 101 and the north end of San Jose–Mineta Airport. The second (No. 2) lies at the corner of Martin and De La Cruz Roads. Hides were loaded onto squeaking *carettas* (oxcarts), headed for the dock later known as Alviso. (Courtesy U.S. Geological Survey.)

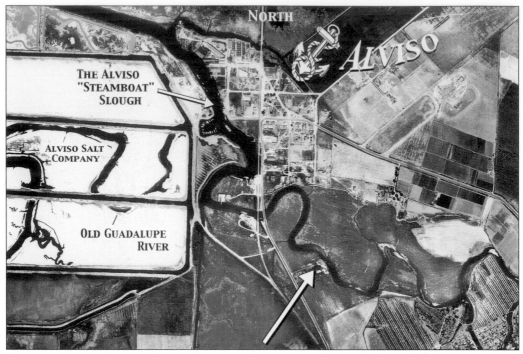

EMBARCADERO OF SANTA CLARA REGION. Alviso is located one mile from the bay on an estuary. This remarkable view looks down on the first mission dock and shows where the Guadalupe later connected to the Alviso Slough. Note the meandering river, which traveled two more miles until it reached the bay. River travel was slow, limited to small steamers like the *Mint*, *Fire Fly*, and the *Sacramento*. (Courtesy U.S. Geological Survey.)

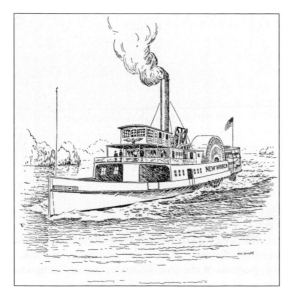

STEAMBOATS ON THE RIVER. In 1849, the *Sacramento* became the first scheduled steamboat into Alviso on the Guadalupe River. In 1851, boatmen familiar with the location observed that a slough from the bay ended close to the river dock. After early horse-drawn "Madison" dredging connected the river and the slough, bigger vessels like the *New World* came through. First came the Chileno sloop the *Saladonia*, followed by the steamboat *Boston*. This new channel, a mile shorter, became known as "Steamboat Slough." The old Guadalupe was abandoned, later diked for the Alviso Salt Company, pictured in the map above. (Courtesy Stanford Press.)

RANCHO LIFE. The day began with prayers, including rosaries and books of novenas to *Nuestro Senora de Guadalupe*. After a simple breakfast, women worked at home and *vaqueros* (cowboys) worked on the range. Cowhides became "leather dollars" that were used to barter for supplies and sold to factories in New England and Europe. *Californios* (native-born Hispanics) balanced work with rounds of feasting and gaiety. A fandango was a festival with dancing that sometimes lasted for days. (Courtesy History San Jose.)

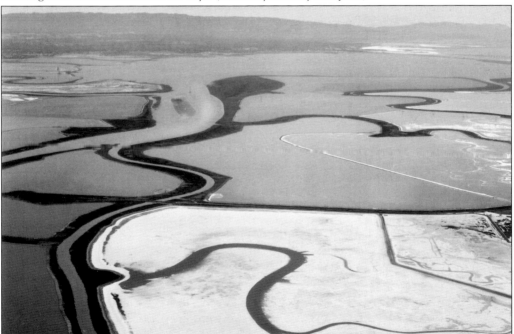

RIVER RUNS BY SALT FARMS. The Ohlone taught the Spanish to farm for salt. Since the mid-1870s, salt farming has constrained a considerable portion of the bay. The Alviso Salt Company extended to South Palo Alto. (RB)

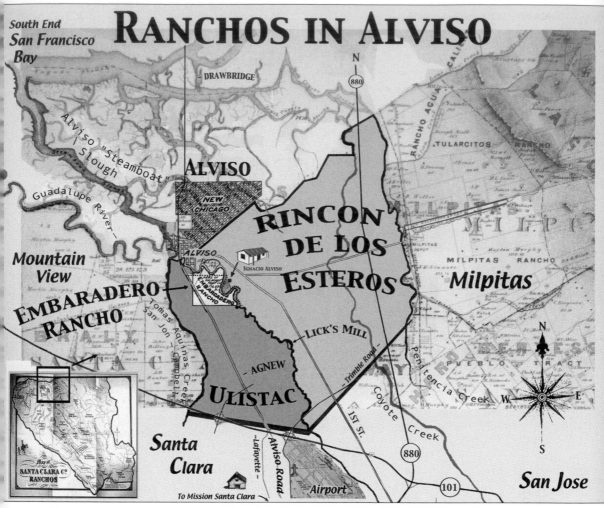

RANCHOS IN ALVISO

South End San Francisco Bay

DRAWBRIDGE

Alviso "Steamboat" Slough

Guadalupe River

ALVISO

NEW CHICAGO

ALVISO

IGNACIO ALVISO

EMBARADERO RANCHO

Mountain View

RINCON DE LOS ESTEROS

Milpitas

LICK'S MILL

AGNEW

Tomas Aquinas Creek San Jon Campbell

ULISTAC

Santa Clara

Lafayette

Alviso Road

To Mission Santa Clara

Airport

San Jose

RANCHOS AROUND ALVISO. During the Rancho period (c. 1822–1850) boundaries were large rocks, cliffs, gullies, creeks, and rivers. People told where they lived based on the rancho or who owned it. What we call Alviso today fell within three ranchos:

RANCHO RINCON DE LOS ESTEROS (estuary corner, bend, or edge) embraced 6,352.90 acres. It spread eastward from the Guadalupe River to today's Milpitas and south to Highway 101 and halfway to Pueblo San Jose. Originally granted by Governor Alvarado to Juan Ygnacio Alviso in 1838, his descendants (Rafael Alviso et al) sold a patent to Ellen White in 1862 (transferred in 1872), and to Francisco Berryessa et al in 1873. By then, it included Port Alviso and James Lick's flourmill.

RANCHO ULISTIC (from the Costanoan, at Ulis) covered 2,217.09 acres of Agnew-Alviso lowland between Guadalupe River and Tomas Aquinas Creek. Pio Pico, the last Mexican governor of California, granted it to the Santa Clara Mission Indians, Marcelo Pio and Cristobal, in 1845. Jacob Hoppe, the first American postmaster of San Jose, later owned the ranch.

RANCHO EMBARCADERO DE SANTA CLARA (port or landing) lay in the northern Alviso area. Granted by Governor Pico to Barcilia Bernal in 1845 (and upheld by Roosevelt in 1936), it occupied a small triangle (only 196.25 acres) of land. Here padres and rancheros loaded agricultural products onto boats. This was the last Mexican land grant to receive a United States patent. (RB)

ENCARNACION PINEDA, 1864.
Descended from Nicolas
Berryessa, whose grant extended
to Alviso, Pineda's relatives had
been killed or persecuted by Anglo
settlers. Many married the widows
to gain their land. Educated at
Notre Dame in San Jose, Pineda
did not marry. Instead she wrote
articles on early California and
a book, *El Cocinero Espanol* (or
The Spanish Cook). She ignored
Yankee ingredients giving a taste
of the genteel rancho life of "la
gente de razon." Like novelist
Maria Ruiz de Burton, who first
challenged American conquest
and Mexican stereotypes in *The
Squatter and the Don* (1885),
Encarnacion's voice was silenced
until recently, when scholars like
Valle let 19th century Latinas at
last speak out. Pineda lived on the
Alviso Road. (Courtesy University
Santa Clara.)

EL COCINERO ESPAÑOL

Pescado asado ahumado con laurel
GRILLED FISH SMOKED WITH BAY LEAVES

After cleaning the fish, wipe it dry and spread with a mixture of salt, pepper, lemon juice, and olive oil.

Put in on the grill, and place some bay leaves on the coals under it from time to time so the fish receives all the smoke.

Turn the fish frequently, basting it with the above ingredients until golden.

Serve with finely chopped green onions and parsley.

RECIPE FROM EL COCINERO ESPANOL. This timeless fish recipe resembles those in today's *Sunset Magazine.* (Courtesy University of California Press.)

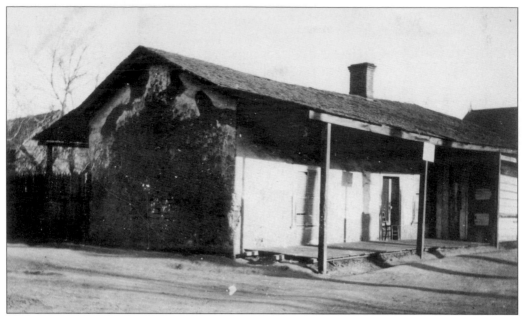

HOME OF YGNACIO ALVISO (1772–1848). Juan Ygnacio Alviso was the fourth child of Domingo Alviso (1738–1777) and Maria Angela Trejo (1742–1803). Domingo Alviso came from Sonora Mexico into Northern California with the De Anza party. Ygnacio's home was one of the earliest structures in the area. Born in 1772, five years before his father, Domingo, died, Ygnacio married Maria Margarita Bernal (1781–1828) and died in 1848. (Courtesy History San Jose.)

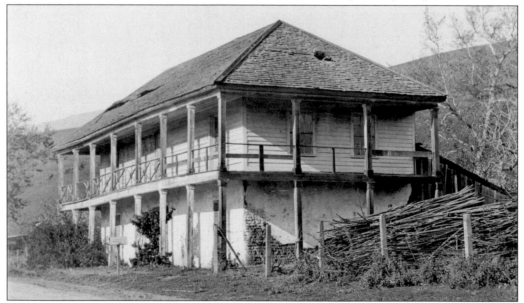

JOSE MARIA ALVISO HOME (1798–1853). Milpitas has preserved Domingo Alviso's grandson's home, the last Monterey-style adobe in the Bay Area. Rancho Milpitas was granted to Nicolas Berryessa in 1834 by San Jose's *alcade* (mayor). In 1835, Governor Castro gave the rancho to Jose Maria Alviso. Murder, a suspicious fire, and a large protest march erupted. Finally, in the 1840s, the adobe was built for Jose Alviso, who married Juana Galinda, while his cousin Jose married her sister. (Courtesy San Jose Library.)

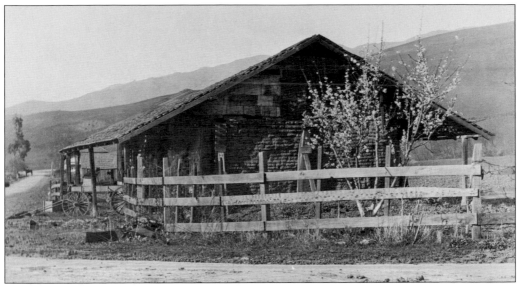

JESUS CASTO/JOSE ALVISO ADOBE, 1900. This adobe structure was one of four such buildings located on over 3,000 acres of Rancho Milpitas at Calaveras, Piedmont, and Uridius Roads. Jose's daughter Maria Josefa married Jesus Maria Casto. The house was lost around 1940. One of the three worker's cabins remains, but may be sold for redevelopment. (Courtesy Donna Breitels.)

ON MILPITAS RANCHO, 1910. Pictured left to right (first row) Josephine Sepulveda (Aloisius' sister), Maria Alviso Sepulveda, Caroline Canelo, Muriel Taylor Berryessa (wife of Anthony Berryessa); (second row) Louie Sepulveda Jr., Bartolome Sepulveda, Josie Alviso (granddaughter of Maria de Los Angeles), Louie Sepulveda Sr. (Aloisius), Anthony Berryessa (grandson of Bartolome and Maria). "There really weren't a lot of people around and the Alvisos and Berryessas married other Californios and became intermingled. They'd come up with De Anza from Mexico and later married gringos." (Courtesy Donna Breitels.)

MARIA DE LOS ANGELOS ALVISO (1843–1920). The youngest of Jose and Juana Alviso's nine children was the last born in the Alviso Adobe. As a child, she traveled by oxcart to mission church. At sixteen, she broke with tradition. She wished to marry quickly and eloped but had to wait for permission from church and family, granted after she and her "intended" had lived for a while with his parents in San Jose. (Courtesy Donna Breitels.)

JUAN FELLS SEPULVEDA, 1858. Maria de Los Angelo's son Juan is pictured here as an infant. He would become the father of John Morgan Sepulveda, and grandfather of Donna Sepulveda Breitels. (Courtesy Donna Breitels.)

RED AND GOLD CHEST. Donna Sepulveda Breitels treasures the Alviso heirlooms passed down to her and her family—silk dresses with chiffon and beads sewn by hand. (Courtesy Donna Breitels.)

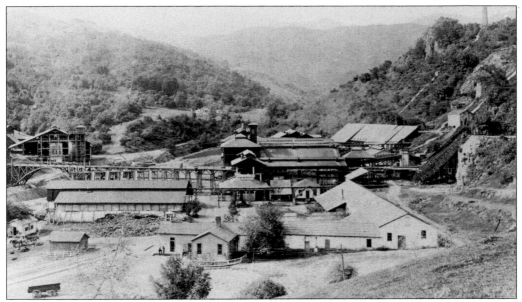

NEW ALMADEN MINES, 1885. In this view of the Reduction Works, the tramway (at right) descends into the mines. From roasting furnaces, mercurial flames passed up a brick chimney flume on the hill. It formed a landmark for mines that fed quicksilver through Port Alviso en route to the gold rush. California became mythical in the world's imagination. The significance of this mine, and Port Alviso, cannot be underestimated. (Courtesy New Almaden Quicksilver Mining Museum.)

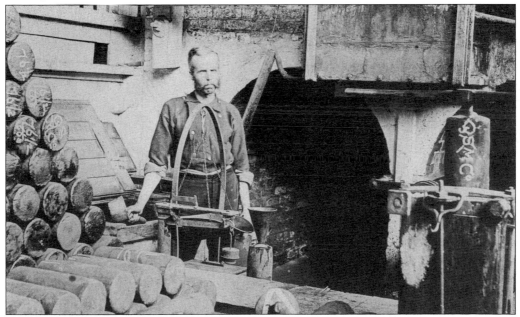

NEW ALMADEN MINER. Miner Henry Tregoning fills an iron flask with quicksilver. Down in the mines, Mexican miners lit candles to Our Lady of Guadalupe for protection. In order to process gold and silver ore headed through Alviso, mercury was needed. During the Civil War, President Lincoln tried to confiscate these mines. The dangers of mercury exposure to miners like Henry were not then known. (Courtesy New Almaden Quicksilver Mining Museum.)

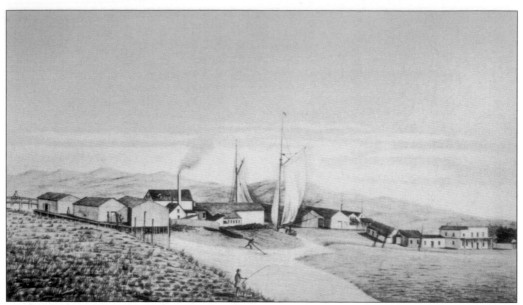

PORT ALVISO ETCHING, 1856. Peter H. Burnett, Charles Marvin, and Jacob Hoppe surveyed Alviso in 1849. In 1852, Alviso was incorporated, and extensive plans were drawn up to make it a terminus for stage lines and a hub for shipping and transportation between the north and south bay. (Courtesy The Bancroft Library.)

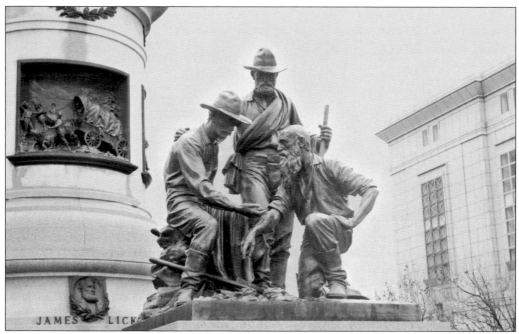

PIONEER MONUMENT. James Lick arrived in San Francisco, days before California gold was discovered. Though he farmed the Alviso area, he left $100,000 for a San Francisco "statuary emblematic of significant epochs in California history." The statuary featured Native American, Spanish, and this bronze of forty-niners by Frank Happersberger (1859–1832). Moved after the 1906 earthquake, it stands near San Francisco City Library. (RB)

Capt. John Martin House. Located at 1080 Catherine Street, this small frame house is one of the oldest buildings in Alviso. Born in Germany in 1825, John Martin was orphaned and took to the sea at 16. He came to New York in 1842, then went to Chile and shipped for San Francisco in 1849. As one of Alviso's first captains, Martin managed the Empire Warehouse. He and J. S. Carter built the schooners *Maggie Douglas* and *Nellie Carter*. (RB)

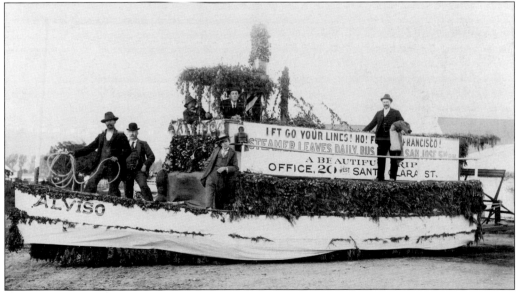

Parade Float Honors Alviso, c. 1910. Capt. John and Theresa Borden Martin (a native of Ireland) married in 1862 and had 11 children. Captain Martin's eldest son, John T. Martin, is listed as "Gen'l Agent" on Alviso Steamboat advertisements (see page 36). He appears to be the man standing above the sign. The man in the wheelhouse bears a likeness to town founder, Jacob Hoppe, and could be his son. (FH)

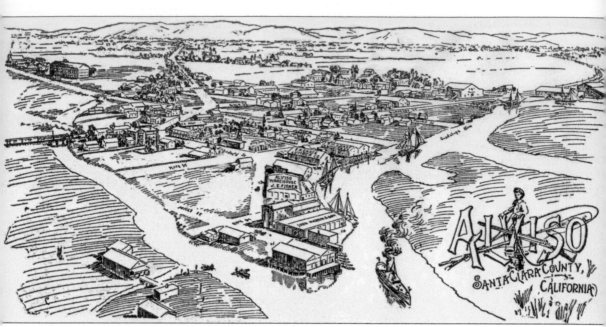

LIFE IN ALVISO, 1892. This bird's-eye-view drawing captures the whimsical nature of the town and the sense of promise of great things to come. The youthful sailor holds a chain and stands with an oar, a fishing pole, and muskets, the tools of a Far West port. (Courtesy San Jose Library.)

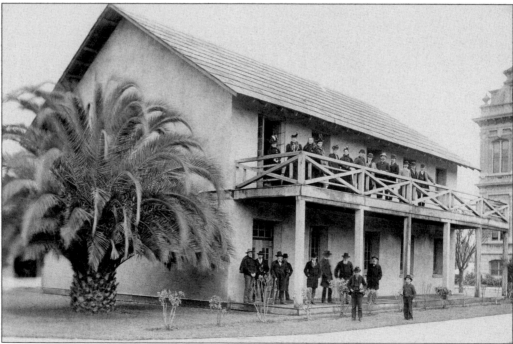

CALIFORNIA BECOMES A STATE. This replica of California's first statehouse was built in 1899 to commemorate the 50th anniversary of the California State Legislature. San Jose had served as California's first state capital from 1849 to 1851. The huge rainfall of 1850—and promise of a grander statehouse—made the legislators think again. They would move it to Vallejo (who gave it over to Benicia) in 1852. (Courtesy Milpitas Historical Society.)

CALIFORNIA'S FIRST GOVERNOR. Born in Tennessee in 1807, Peter Burnett worked as a storekeeper, lawyer, farmer and judge. He defended Joseph Smith and other indicted Mormons. As an Oregon legislator, Burnett proposed arresting all free Negroes and flogging them every six months until they left Oregon. In 1849, before California's statehood, Burnett became governor. His first annual address drew legislative criticism. He resigned from office. Burnett converted to Catholicism, wrote a book about it and is honored at Mission Santa Clara. (Courtesy History San Jose.)

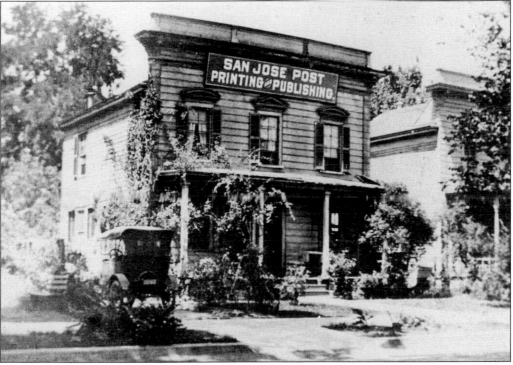

GOVERNOR BURNETT'S ALVISO RESIDENCE, 1915. This building was once the home of California's first governor. It stood on El Dorado Street between Catherine and Elizabeth Streets, near the Trevey store. Constructed in 1850, it was dismantled in 1852 and moved, board by board, to 441 North First Street in San Jose. (Courtesy History San Jose.)

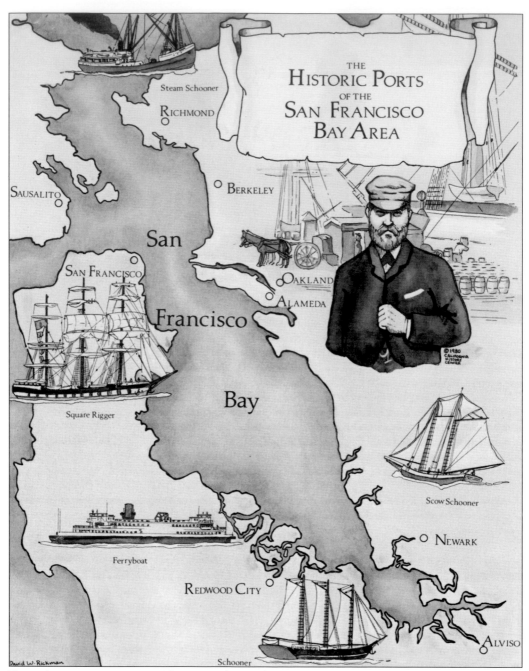

Steam Schooner

THE
HISTORIC PORTS
OF THE
SAN FRANCISCO
BAY AREA

RICHMOND

SAUSALITO

BERKELEY

San

SAN FRANCISCO

OAKLAND

ALAMEDA

Francisco

Square Rigger

Bay

Scow Schooner

Ferryboat

NEWARK

REDWOOD CITY

ALVISO

Schooner

David W. Rickman

©1980
CALIFORNIA
HISTORY
CENTER

PORT ALVISO ON THE BAY. Alviso was the southernmost port on the San Francisco Bay and the entrance to San Jose, the state capital. (Courtesy California History Center.)

Two

PORT ALVISO

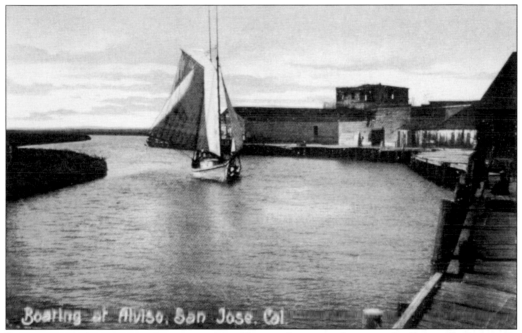

SCHOONER IN STEAMBOAT SLOUGH, 1840. Here a schooner sails in past the flourmill. Originally a path led from Mission Santa Clara down the meandering Guadalupe River to a dock two miles from the bay. This would become Port Alviso. In 1838, author Richard Dana recorded slough trade between Mission Santa Clara and Mission San Jose with hundreds of hides loaded into mission-built boats. American Indian "neophytes," who refused to help load, angered sailors, who carried hides on their backs. Indian "lighters" would guide the barges out to waiting ships. Later vast loads were hoisted onto barges bound for San Francisco. Three sail and steam lines operated. Passenger service on steamboats began during the gold rush years. In 1851, boatmen discovered that the Alviso Slough route was a mile closer to the bay and the name Alviso replaced Embarcadero de Santa Clara. After 1864, the railroad slowed port activity and plans for a deepwater port never materialized. Recreational boating continued and the South Bay Yacht Club emerged, but over time, silt from hydraulic mining in the Sierras raised the bay floor about eight feet, and the yacht club had to be moved. In the 1970s, offbeat boat builders continued to enjoy this community until environmental laws closed the port. (Courtesy William Wulf.)

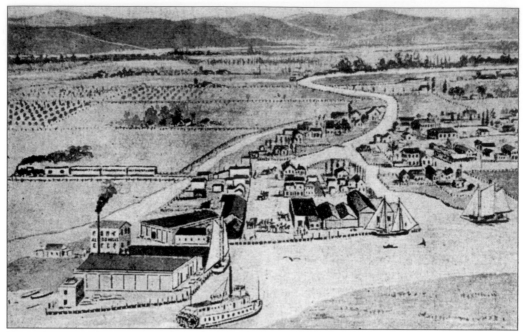

PORT ALVISO, 1878. By now, the embarcadero was named after Ynacio Alviso. This is one of the earliest drawings of the Alviso Harbor. Alviso's large wheat mill supplied grain to San Francisco and as far as China. When the tide was up, sailors could bring schooners into Alviso Harbor. A schooner was rigged fore and aft with two or more masts. When the tide was down, only scows could be towed in. This illustration reveals a lot about Alviso's brief history as a thriving port. (Courtesy Santa Clara County Pioneer Papers.)

ALVISO WAREHOUSE, 1860. This early photograph of the warehouse (drawn above) shows extensive piling at the dock's edge for large boats. By 1851, approximately 100,000 people had come into the state. Wheat from Alviso Mill helped feed the newcomers. The flood of 1849 and 1850 interrupted Alviso's boom. It sent the capital out of San Jose. (Courtesy William Wulf.)

SCULLING A ROWBOAT. To "scull" means to work a long oar from side to side over the stern of a boat, or it can mean the small boat used for sculling. In the 19th century, Alviso passengers would be sculled to their departure boat like this schooner, the *Portia*, in the background. (Courtesy San Francisco Maritime Historical Park.)

HAY SCOW ON THE BAY. Before the internal combustion engine, the scow schooner operated over inland waterways. The 19th century moved on horsepower, as the 20th would on gasoline. The towering load of hay on deck gave rise to its name. The *Alma* and the *Annie L.* (above, middle) were frequently seen in Alviso. Potatoes, beans, bran, oats, and wheat were also shipped from the hinterland. (TL)

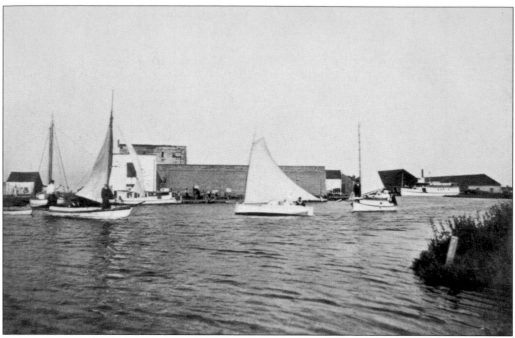

INSIDE ALVISO HARBOR. In 1850, Alviso was the port entrance to California's capital. Ships entered and exited the busy harbor. Wagon wheels clattered, steam engines chugged. Throngs of newcomers and curious crowded the wooden docks—farmers and otter fur traders, miners, gamblers, and American Indians, Asian men far from home; fallen belles and churchgoing women wound their way through Alviso's heyday. For this brief shining period, Alviso was a great port and transportation hub. (Courtesy *San Jose Mercury*.)

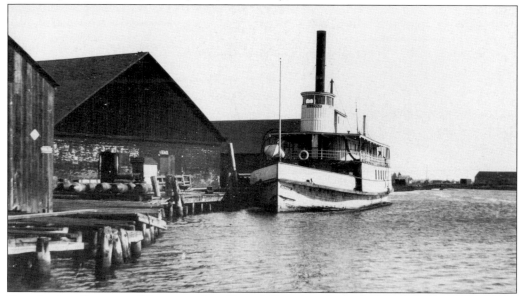

THE ALVISO STEAMER. The steamship *Alviso* followed in the wake of other vessels. This first passenger steamboat was joined by others; including the *Fire Fly*, the *Saladonia* and the *Jenny Lind*. The *Alviso* steamer (visible above) was built in 1895 and burned in 1920. (Courtesy Milpitas Historical Society.)

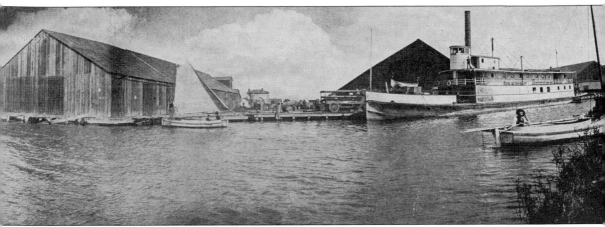

ANOTHER VIEW OF THE STEAMER, 1895. The Sketch and Report Bulletin of 1899 shows the captain standing, arms crossed, outside the wheelhouse. The "Steamer-Alviso" horse-drawn stagecoach waits on the dock to the left of the bow (see advertisement on the next page.) The *Alviso* steamer made its daily run to San Francisco, leaving at 7:30 a.m. and returning the following morning at 10:00. Produce moved at $1 a ton; passenger fares were 50¢. (Courtesy William Wulf.)

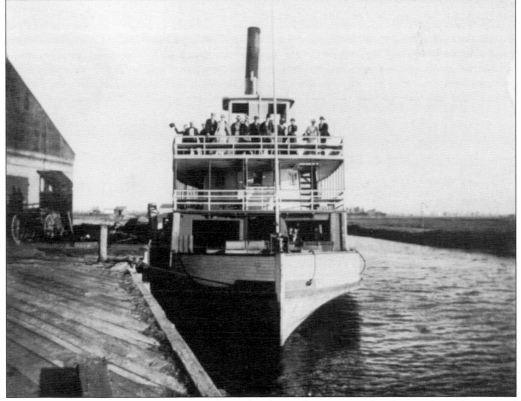

STEAMBOAT SLOUGH, 1900. The slough was home to schooners, yachts, barges, houseboats, and scows. Steamboats carried people and produce to San Francisco through the 1920s. The power of wind and tide has always been respected by sailors. Steam power was a revelation in its time and offered an infinite future for nautical travel; however, steam could be dangerous. (Courtesy Alviso Library.)

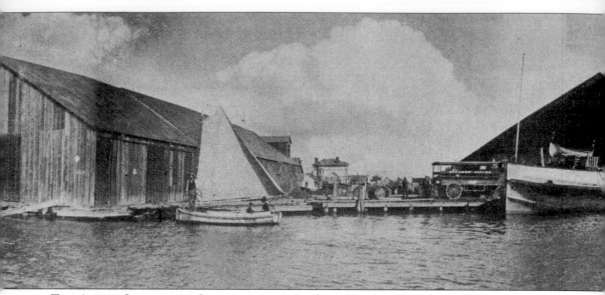

THE ALVISO STEAMBOAT COMPANY, 1896. Looking east down Elizabeth Street, a variety of cargo litters the dock. The Tilden house is visible on the left, as is the house of Capt. J. T. Martin, whose name appears at bottom of this advertisement. (Courtesy William Wulf.)

Alviso Steamboat Co.

DAILY SERVICE

FREIGHT AND PASSENGER

SAN JOSE and
SAN FRANCISCO

Steamer Alviso

E. V. RIDIOUT, MASTER

STAGE leaves the St. James and Jefferson Hotels daily (except Saturdays) at 6 p. m. and connects at Alviso with the Boat for San Francisco.

RETURNING Steamer leaves Washington Street Wharf, San Francisco for San Jose daily (Sundays excepted) 10 a. m.

Fare 75 cts.

TICKETS FOR SALE AT

7 WEST SANTA CLARA ST.,

ST. JAMES HOTEL, AND

JEFFERSON HOTEL.

J. T. MARTIN, Gen'l. Agent,
7 West Santa Clara St., San Jose

WM. BOOTS, JR., Agt. W. H. SMITH, Agt

ALVISO SAN FRANCISCO

STEAMBOAT POSTER, C. 1890. Alviso was once a transportation hub. The warehouses were important; both sailboats and steamboats were unloaded there. Produce from Santa Clara Valley was hauled up today's Lafayette and First Streets. It was an exchange point where outgoing and incoming cargo was off-loaded and on-loaded. Members of the community hated the railroad, which had come down the peninsula and bypassed Alviso, quelling its commerce. Nonetheless, scheduled passenger service spanned two centuries. (Courtesy Walter Hopkins.)

JACOB HOPPE (1815–1853). An Alviso street honors Hoppe, San Jose's first American postmaster. He played a leading role in the state's inception, editing its first newspaper, the *Californian* of San Francisco, and serving as a member of the constitutional convention. Hoppe helped found Alviso—in association with Charles White, businessman and former mayor of San Jose, and Bernard Murphy of the prominent agricultural clan. The popular young civic leader served twice on the city council and advocated for public education. On the morning of April 11, 1853, the three Alviso benefactors boarded the *Jenny Lind* steamer, headed for San Francisco. (Courtesy History San Jose.)

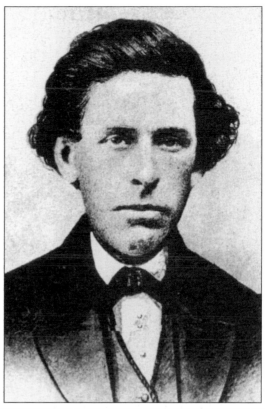

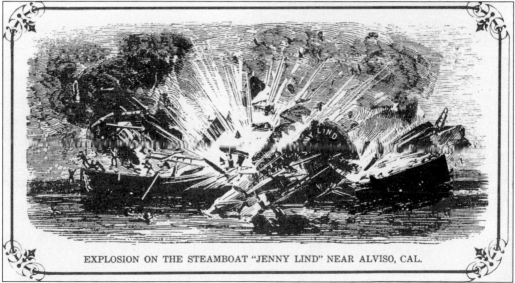

EXPLOSION ON THE STEAMBOAT "JENNY LIND" NEAR ALVISO, CAL.

EXPLOSION OF THE JENNY LIND. A little past noon, the *Jenny Lind* passed Pulgas Rancho, four miles north of Alviso. The boiler head blew, and steam shot through the bulkhead where passengers sat eating dinner. The *Daily Alta California Newspaper* cried—21 dead, 19 scalded. Hoppe lingered for six days after the death of his friends. He passed away in San Francisco. According to Alviso Rotary president Dave Warner, the *Jenny Lind* disaster took Alviso's heart and future. (Courtesy Alviso Library.)

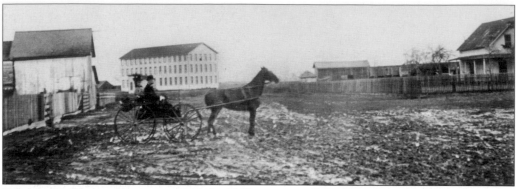

WHEELER'S WATCH FACTORY, 1890. In 1889, promoter P. H. Wheeler wanted to relocate his defunct San Diego watch factory in Alviso (pictured left of center, behind carriage). To escape his creditors, Wheeler came up with a plan to sell lots in Alviso, where land values were low because the railroad had bypassed its 900 inhabitants and storage businesses. Promoters laid streets out on paper (copying Chicago, Illinois, also near farms and water) and made plans to dredge Alviso Slough and lay broad track to siphon off San Francisco's coal storage business. Steam tugs were built, and dredging stock went quickly. San Jose real estate firms stayed open nights, selling Alviso lots at $5 to $200. Over his creditor's objections, Wheeler finally got a favorable ruling from the San Diego court. Loading his factory on the overnight train on Friday, by Monday morning he'd dropped it off in Alviso! (Courtesy California Historical Society.)

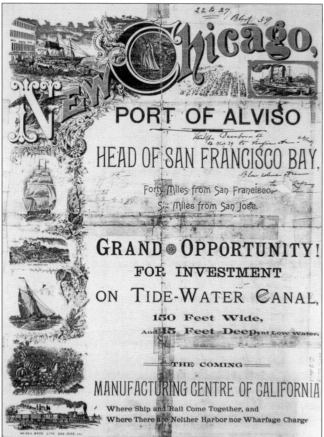

THE NEW CHICAGO PROMOTIONAL POSTER. This poster, which calls Alviso "a New Chicago of the Far West," illustrates three important recurring Alviso themes: shifting demographics, outside forces controlling the town's future, and the dream of a deepwater port. Though it ultimately failed, street patterns and names today mark events of the early 1890s. (Courtesy California Historical Society.)

FATHER AND DAUGHTER. In 1917, Miles Hollister and daughter Belle Davee took the train to the San Francisco beach Santa Cruz for his 90rh birthday. This Civil War captain came to Alviso in the 1890s. Following her father, Belle served as Alviso postmaster and census taker for 44 years until 1940. She was honored under Pres. Franklin Roosevelt. (FH)

GRANDAUGHTER ALICE DAVEE HUXHAM. Belle Davee's daughter Alice assumed the position of police judge from Marie Bacigalupi, who had assumed it from her father. In 1947, the *San Jose Mercury-Herald* quoted Judge Alice Huxham: "I listen carefully to what both sides have to say, read the law, and render judgment." (FH)

THE HOLLISTER'S NEW CHICAGO HOME. Only three New Chicago houses were built. This one housed Miles Hollister, who had come to Alviso from Minnesota and Susan Hunkins with his wife of the Naglee Park, San Jose, family. Her sister sang for the Metropolitan and Boston Symphony. When daughter Belle was widowed, she returned to her parents' house. (FH)

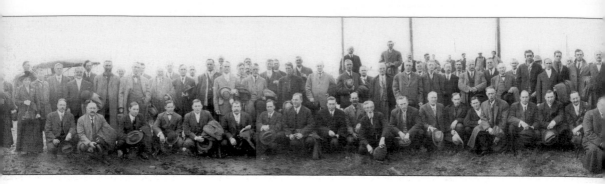

SAN JOSE DEEPWATER PORT COMMITTEE, 1906 (ABOVE). This huge committee convened at the yacht club when hopes soared for a deepwater port. At 4 feet wide, 15 inches tall, the banquet-camera photograph is the largest image in the yacht club's collection. A total of 155 gentlemen and one lady pose on a muddy day, weeks before the 1906 quake would shake the bay. After several deepwater campaigns, the Port of Oakland opened in 1927 and added container shipping in the 1960s. Alviso's chances sank. (SBYC)

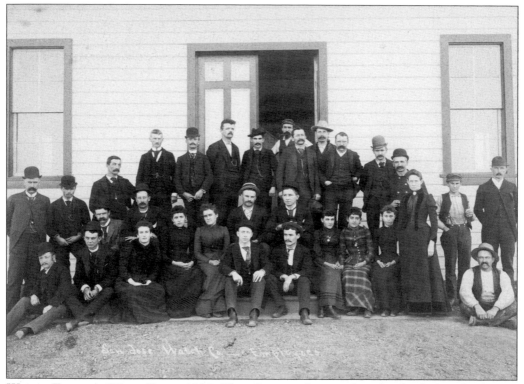

WATCH FACTORY WENT BUST, 1890. This photograph was taken the day before the factory opened—and closed. Only three watches were made. Even with Elgin as designer, the factory cost was too great. The fictitious dredging company vanished; Wheeler fled lawsuits and declared bankruptcy. According to Stanford's David Loring, "The factory and dyes were later sold to a Japanese firm which sent out watches all over the world stamped: 'Made in San Jose California.'" Alviso's hopes sank in the mud. (Courtesy California Historical Society.)

40

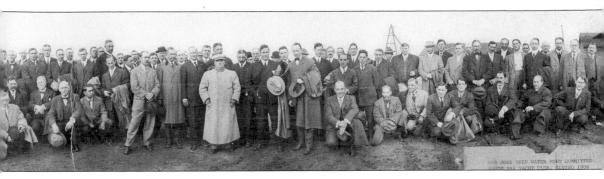

NEW CHICAGO SPECULATORS (RIGHT).
Paul Philips states, "Alviso had again been promised greatness, only to be disappointed by circumstances beyond its control." Wheeler's directors included, from left to right, railroad commissioner John Rea, James McKenzie, and unidentified. Fruit-grower Penniman, Supervisor Austin, realtor Darby, and struggling San Jose lawyer Roberts made up the rest. Wheeler promised them warehouses, mills, and "manufactories" along waterfront properties for future car shops, sugar refineries, spinning mills, boat and shoe factories. It was a fish story. (Courtesy California Historical Society.)

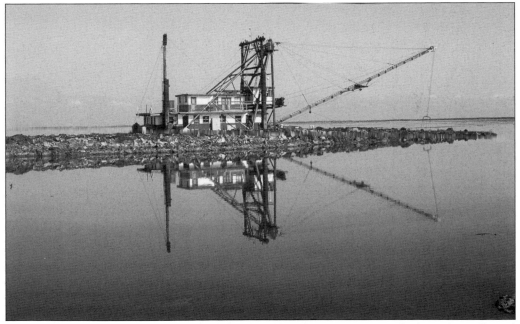

BOATS DREDGE THE BAY. The Mallard and the Edward, two prominent dredgers, have floated in the bay since the 1900s. A clamshell scoop was designed in the Bay Area. The name Dutra was synonymous with dredging the bay. (RB)

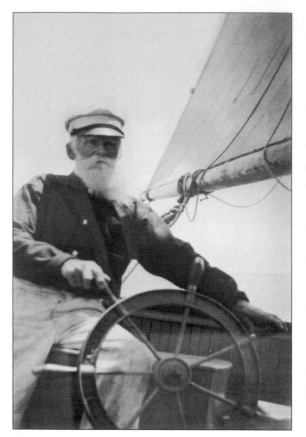

COMMODORE MCKEE (1831–1907). In 1888, Joseph Olcott McKee (McKee Road, San Jose) helped form the South Bay Yachting Association, reformed in 1896 as the South Bay Yacht Club. He was joined on the first founding board by vice commodore Dr. Hume Spencer, treasurer Samuel E. Smith, secretary J. E. Auzerais, measurer Frank Davis, and directors Oliver Ortley and H. G. Coykendall. The South Bay Yacht Club on Hope Street has anchored Alviso across three centuries, six wars, personal tragedies and joys—and risen up after subsidence and floods. In World War II, it assisted the U.S. Coast Guard. From 35 members, the club grew to conduct local races, regattas, and cruises around the bay from Drawbridge, Newark, Angel Island, Drake's Bay, and Half Moon Bay. Some intrepid sailors made it to San Diego, Baja California, Hawaii, and as far south as the Sea Islands. In 1996, McKee's descendant, Kenneth McKee Coykendall, then 97, helped compile the club's history, which included frequent visits by well-known author Jack London. (SBYC)

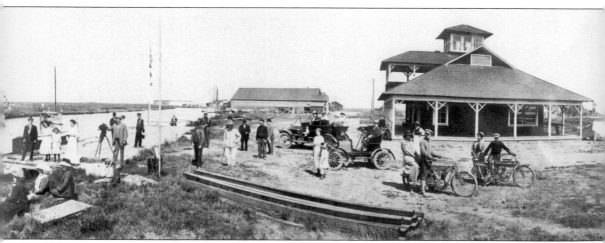

SOUTH BAY YACHT CLUB, 1915. When California moved its capital from San Jose to Benicia, Commodore McKee carried the state documents on his boat. Alviso's fortunes went out with the tide, but the yacht club survived. Built in 1903, it was known as "The Blue Lady." However, club historian Russ Robinson says green paint was found during the frantic relocation after the 1983 flood. Subsidence forced levees to be built, and this picturesque scene has been reclaimed. (SBYC)

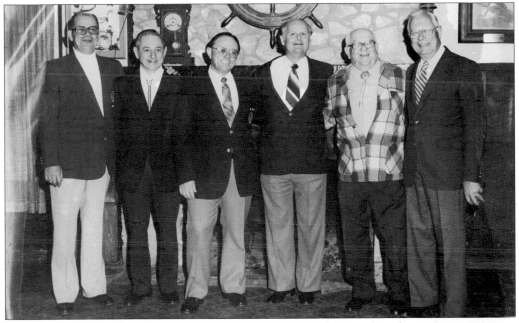

THE COMMODORE TRADITION. In 1985, six past commodores gathered to reopen the club on higher ground. Pictured in the photograph above, from left to right, are John Claney (1981), Roy Raymond (1961), Russ Robinson (1978), Jim Norton (1968), Frank Berryessa (1958), and Hank Viehweger. Although there had been a Ladies Auxiliary, it was a men's club for nearly 100 years. In 1986, Commo. Russel Robinson amended the bylaws; women now hold their own memberships. The year 1995 saw the first female commodore, Marlene Inderbitizin (pictured at right). (SBYC)

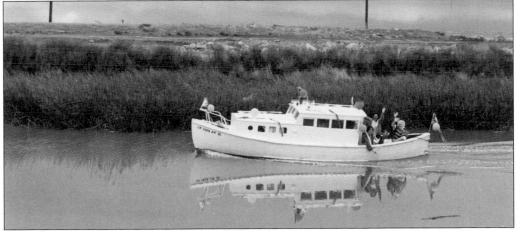

THE WINDY PINK. In this photograph, Frank Berryessa and his wife motor down the slough. Born in Port Alviso in 1912, Frank descended from Nicolas Berryessa of the De Anza expedition. Frank's parents kept pear orchards and hay fields on their 77-acre Berryessa Ranch just south of Alviso. In Frank's boyhood, Alviso suffered setbacks, including closing the Alviso depot and salt company. Frank worked in the cannery and ran a tugboat. He was police chief, port captain, commodore, and owned this surplus lifeboat. When urbanization threatened the marshes, he warned builders. At his passing, donations were designated to preserve Alviso wildlife. (SBYC)

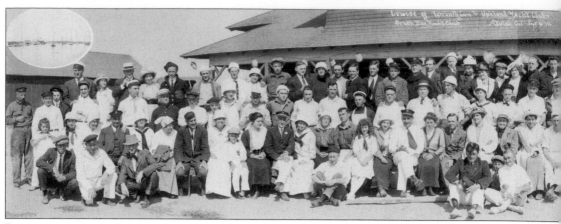

Photography in Alviso, 1914. On September 6, the Oakland Yacht Club joined Alviso's South Bay Yacht Club. An arc lens swept 150 degrees around the large group, wiping their image across the foot-long, silver celluloid film. The South Bay Yacht Club states that Jack London is featured in the center (see detail view on the opposite page, above). Joseph Lawrence of the Jack London Foundation, states, "From looking at other pictures of Charmian [Jack London's wife] . . . I think she would be the woman to the right of whom is supposed to be Jack London. She has her hair up without a hat." Her diary says they took in a San Francisco movie that evening—after

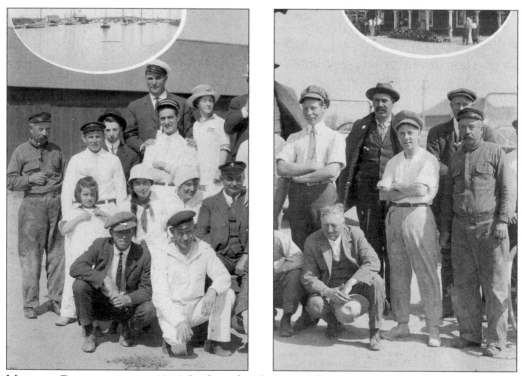

Magical Reappearance, 1914. In these detail views of the panoramic shot above, the seaman on the far left appears to have a twin brother standing on the far right side of the photograph. This club prankster took advantage of the slow shutter speed, outran the camera's pacing mechanism, and reappeared at the other end of the crowd. Even the photographer appears to be in the above photograph, seated under the Swadley Photo signature on the lower right.

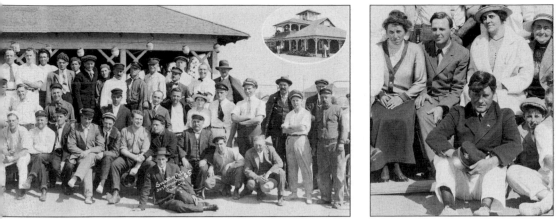

a sailing excursion? The debate continues: some say it's London, others, J. Campbell of Tiburon. On November 22, 1916, the *New York Times* would report London's death, adding, "He leaped into fame as one of the foremost young American authors with *The Call of the Wild* published in 1903." In 1914, when he last sailed to Alviso, London had just finished writing *The Valley of the Moon* and publishing *Mutiny of the Elsinore*. Despite doubts about this particular photograph, it is certain that London sailed to Alviso with his writer wife, Charmian, on their boat, the *Roamer*, as pictured below. (SBYC)

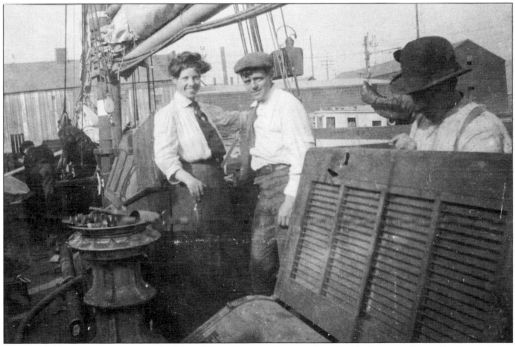

JACK AND CHARMIAN LONDON ON THE ROAMER. Russ Kingman's definitive chronology confirms that London sailed to Alviso on April 11 and October 14, 1914. He and Charmian bought Chinese lottery tickets and got stuck in the muddy slough both times. Married to Jack in 1905, Charmian was an adventurous spirit who was five years older than London, who based many female characters on her. She assisted his work and authored nine books of her own including *The Log of the Snark, Jack London in the Southern Sea, Voyaging the Wild Seas, Our Hawaii,* and *Cross-Saddle Riding for Women.* (Courtesy Huntington Museum.)

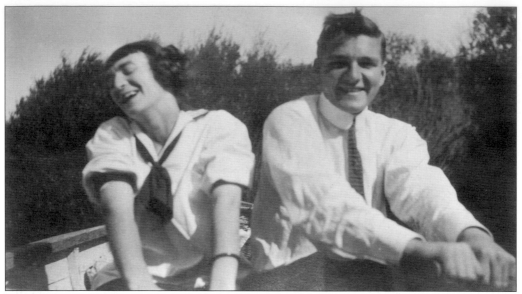

ROWING AMID THE REEDS, 1914. This couple (Alice Huxham and friend) are rowing along a tidal marsh in Alviso. Another young couple in the boat took this picture with an old Kodak, whose manual read, "You take the picture and we'll do the rest." Alice also played piano for yacht-club gatherings. (FH)

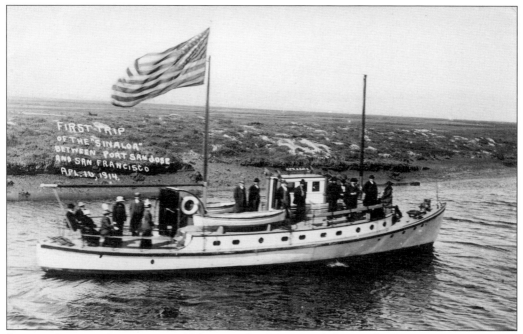

SINALOA LEAVES ALVISO, 1914. This was the first trip of the *Sinaloa* between Port San Jose (Alviso) and San Francisco. This handsome cruiser also offered ocean trips from San Francisco to Santa Cruz. (Courtesy History San Jose.)

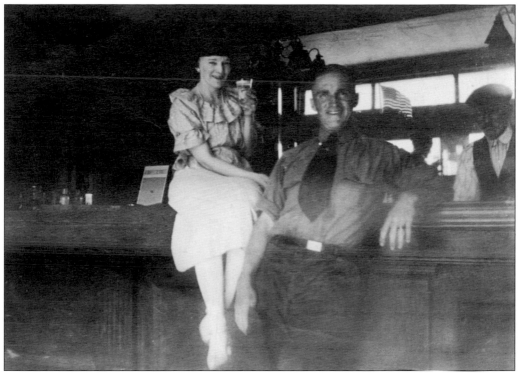

IN THE CHISOLM SALOON. John Chisholm ran this saloon, where Alice Huxham drapes over the bar behind her husband, Fred. Today their son says that London "would come into the yacht club on his boat and hang out in my uncle John Chisholm's saloon or row a lot when he was drying out." Walter Chisolm also remembered riding on the Wade stagecoach as a child. (FH)

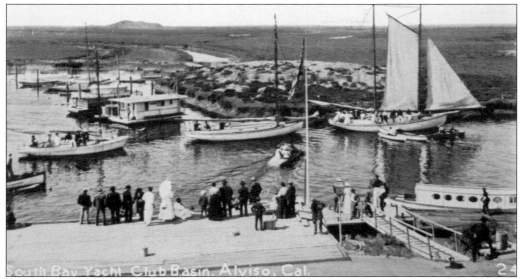

A DAY AT THE YACHT CLUB, 1914. The South Bay Yacht Club Basin is pictured here. (SBYC)

U.S. GEOLOGICAL SURVEY (USGS), MENLO PARK. Retired administrator Avery Rogers remembers concerns about subsidence in the Alviso region beginning in the 1950s. Subsidence pioneer J. P. Portland's abstract described the "intensive withdrawal of groundwater . . . in the San Jose area (that) has drawn down the artesian head as much as 250 feet since 1912." Subsidence reached 12.7 feet by 1967 and over 26 feet to date. (RB)

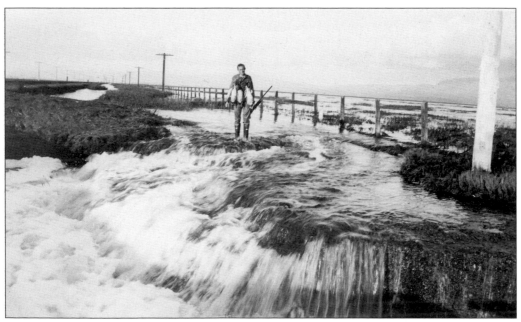

TIDE BEGINS TO CREATE MARSH. This 1933 photograph captures tidal changes beginning to claim the Alviso region. The fence line marks the cattle grazing land, which had been free of tidal activity. Willis Laine is the hunter pictured here. His son Tom Laine says today that tides need to flow in and then out of Alviso, as they did through the 1920s. (TL)

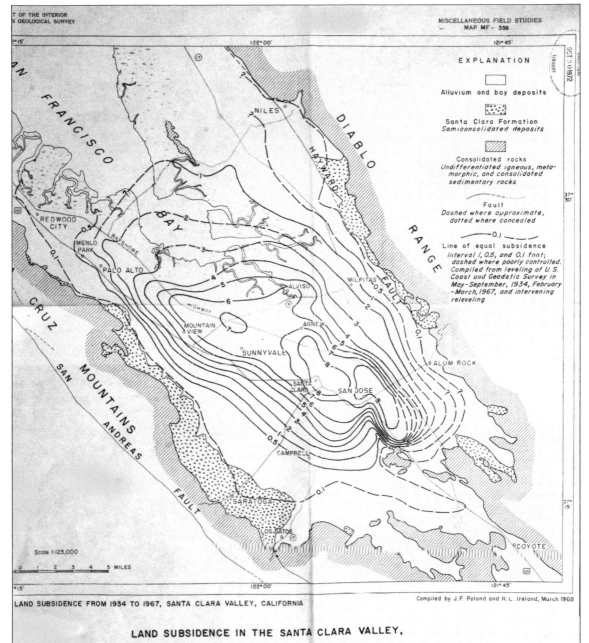

USGS Subsidence Report, 1968. The Santa Clara Valley is the first area in the United States where gradual settling of earth structures to a lower level was recognized and described. Alviso is the lowest point in the valley. Research from 1934 to 1967 was reported in 1968. For Poland's work, Stanford bestowed a full doctorate. The map pictured above shows the first areas of subsidence. The report concluded, "If management can raise and maintain the artesian head at least twenty feet above present levels, subsidence can be stopped permanently." Today percolating ponds are positioned throughout the south bay. Water seeps back down to refill and maintain the subterranean water table. (Courtesy U.S. Geological Survey.)

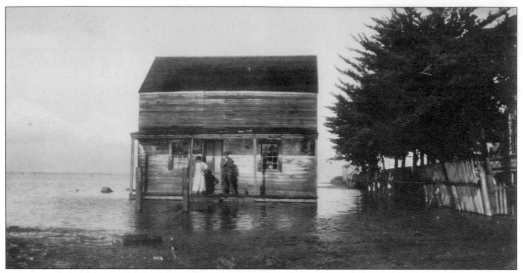

MAROONED IN ALVISO. In 1912, tidal water was first reported in this area across the tracks from the Tilden store. This couple stands on a narrow porch above encroaching seawater. Many Alviso residents remember floods. In 1933, Mayor Willis Laine could stand on the highest point of his house—on the Tilden widow's walk—and look north toward Drawbridge. Behind the house lay flooded fields. The ground sank, and water came right up to the house. (TL)

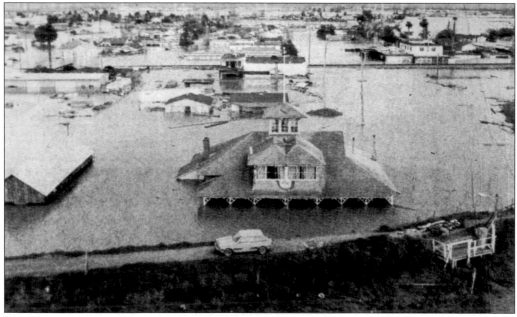

THE FLOOD OF 1983. According to the *Mercury News*, only the roof of the South Bay Yacht club was above the floodwaters. The famous Vahl's Restaurant was forced to close its doors "for good." Fortunately, Vahl's Restaurant and the yacht club persevered. About every 10 years from 1912, significant floods inundated Alviso. (SBYC)

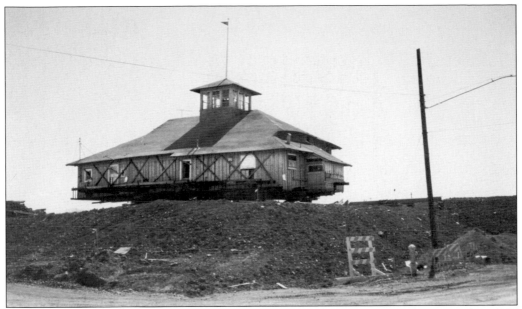

YACHT CLUB ON THE MOVE. The 1983 floods prompted this move to higher ground in 1985 (top). The yacht clubhouse was lifted 13 feet. A new foundation was laid, 100 yards to the north and 20 feet higher (bottom). Plans call for raising the club five more feet in 2006. (Courtesy Russ Robinson.)

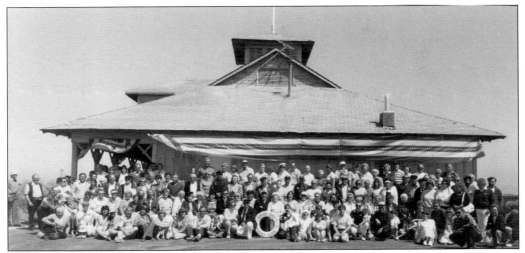

RESTORED CLUBHOUSE. Over 300 people showed up to celebrate the clubhouse's new location. Commo. Clarence Boncher assembled guests for this auspicious photograph. The cupola tower (top) offers a splendid view. Local birds have claimed the rafters. Historian Russ Robinson guards the club's memorabilia, including a proclamation saluting the club as a wartime auxiliary between 1942 and 1944. (Courtesy Russ Robinson.)

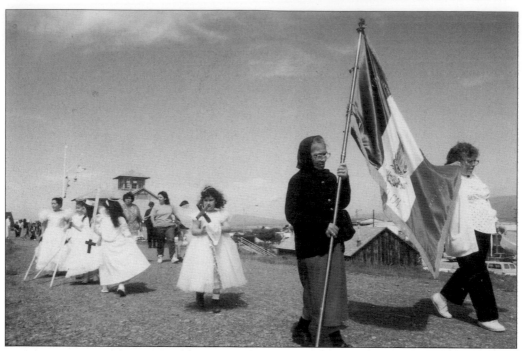

PROCESSION AT THE DOCKS, 1977. The Guadalupanos' Alviso flag leads this annual procession to bless the boats. According to spokesperson Fr. Francisco Rio, "angels" like these "fight off the devil." Judy Sanchez is the child facing center, while Candida Castillo and Lupe Dominguez bear the flag of Nuestra Senora de Guadalupe. (SBYC)

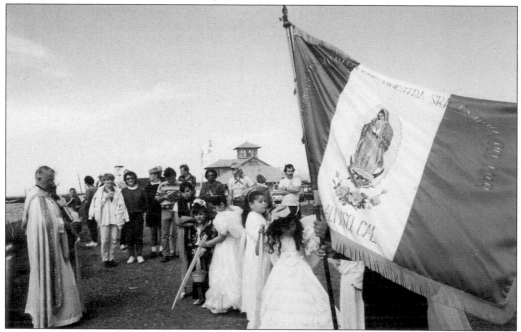

ALVISO FLAG TO GUADALUPE. The Star of the Sea church keeps alive traditions going back to 1777 honoring Nuestra Senora de Guadalupe. Father Stout (left) will offer Mexican bread and flower petals. (SBYC)

Three

HOUSEBOATS, SCHOONERS, AND SCOWS

HULL AT MUDFLAT GALLERY, 1970. This building began as John Jacob Ortley's Union Warehouse—actually an icehouse with eight-foot-thick, brick walls packed with sawdust for cold storage. Once used for union meetings, it is now the Mudflat Gallery. Although Alviso never became a deepwater port, its boat builders remained. Most Alviso boats were built elsewhere, but the need for maintenance led to a thriving local repair business. Alviso-fabricated watercraft could meet the low draft requirements of tidal waters. During World War II, Food Machinery Corporation (FMC) built launch and pullout sites to test PT boats in Alviso, and Liberty-ship bows were fabricated here. After the war, boat builders and dwellers flocked to the Alviso Slough, drawn by cheap rent and access to the water. At least 24 boats were completed. Alviso remained a busy launch and pullout site for boats until 1978. As the slough silted in, dredging became too expensive and damaging to the environment. In 1977, the U.S. Fish and Wildlife Service bought the land along the slough from South Bay Yacht Club north to open water for a wildlife refuge. Boats, now banished, slowly sailed, motored, or were towed away. Land subsidence, further silting, and pollution changed the water's salinity balance, and thick reeds claimed the banks of the slough. (RB)

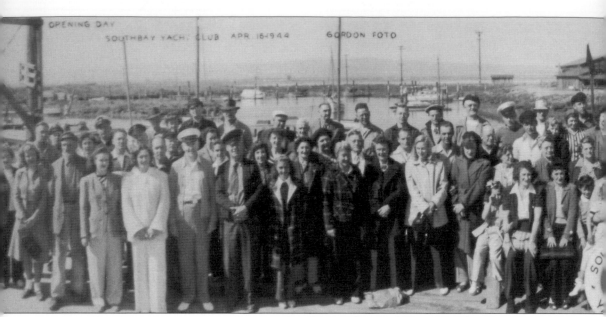

SOUTH BAY YACHT CLUB, 1944. Unity and pride is evident in this opening day "Gordon Foto" taken on April 16. During the war years, the United States became the "arsenal of democracy," and Alviso was no exception. Typewriter firms built rifles, automakers turned out tanks, and millions of Americans migrated to the West Coast to build Liberty ships in yards springing up

EVIDENCE OF LARGE SHIP CONSTRUCTION, 1970. Before World War II, shipbuilding in the United States was not a major industry. But with German U-boats sinking ships off the East Coast within sight of land, England on her knees, and the Japanese conquering Asia and the Western Pacific, it was essential to build large, strong U.S. Merchant Marine ships to carry combat supplies to Allied fighting forces. (Courtesy Gabriel Ibarra.)

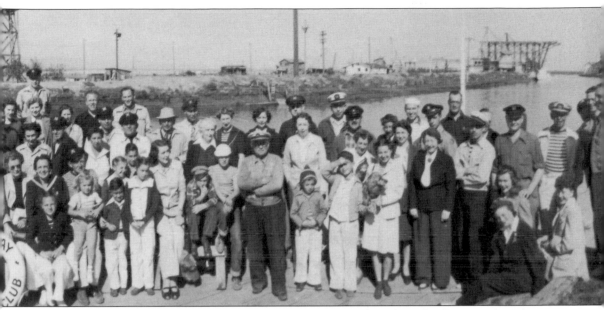

near major cities. Liberty-ship manufacturing was part of the Alviso landscape. The Liberty design modified an earlier British hull. Economical and simple to build, it ushered in an era of prefabricated mass production. Eighteen shipyards built Liberty ships, with one third of the work force being women. Without these ships, the war would not have been won. (SBYC)

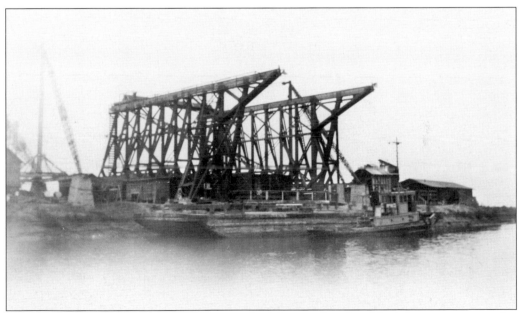

THEY BUILT THE BOW HERE. Welders attached sheets of steel and built bow sections in this cage-like construction. After finishing a section, they would lift it, roll it between two long arms, and hoist it onto the barge. In 1942 and 1943, Mabel Silva (Mattos) worked the night shift at Defore's Cannery with other Portuguese and Italian workers. Ships were welded across the slough behind the cannery. "The moon was shining and welding sparks flew high—Alviso looked beautiful then." (FH)

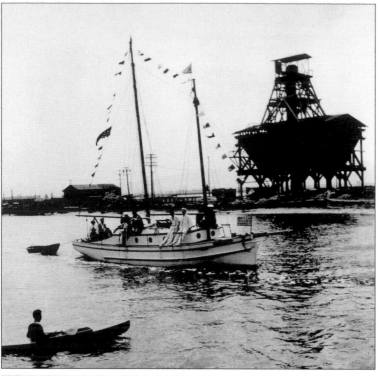

ALVISO SALT COMPANY, 1938. In the 1920s, the Ortley Brothers built a 75-foot salt-washing tower on the west side of Alviso's Steamboat Slough. Dismantled in 1939, its conveyor once fed salt onto barges—emptying 5,111 acres of tidal salt lands from Palo Alto to Alviso. At the height of production, superintendent Andrew Christianson lost his life beneath 25 tons of salt in a bunker near the slough. Despite the tragedy, the business continued. (TL)

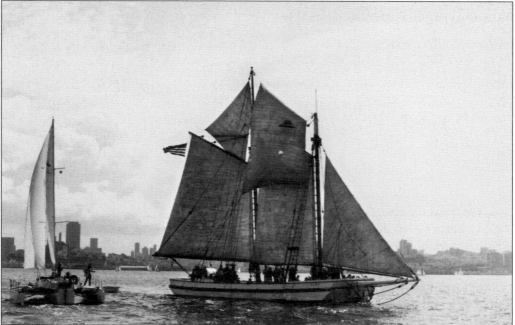

THE ALMA SAILS AGAIN, 1975. Scow schooners once hauled Bay Area cargo like hay and bricks. Built in 1891, the *Alma* was motorized in 1923 and active as a shell dredger until 1955. In 1959, the state park service pulled the *Alma* off an Alviso mud bank and refurbished it using parts from the *Annie L.* Here an Alviso-built trimaran, the *Shelter*, passes the *Alma* hay scow, under sail again on the San Francisco Bay. (Courtesy Skip Wamsley.)

WORKING FOR PG&E. Fred Huxham IV worked the PG&E Patrol for years. Early Alviso PG&E workers stayed at Captain LaMontaigne's 1890s house at 1044 Catherine Street. It was converted to a boardinghouse in 1904. (Some say it is haunted by the ghost of Norbert Gorecki; a later owner, returning to the upstairs bedroom.) (FH)

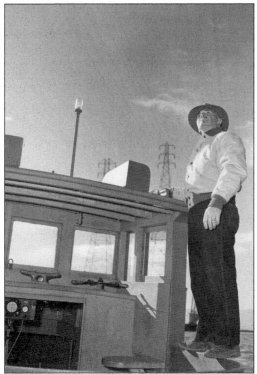

FRED HUXHAM ON THE *SIERRA II.* Huxham's patrol boat, the *Sierra II*, was built by the George Gniese Company near Hunter's Point, San Francisco. Crossing the south bay near Port Marion, he checked for blistered or burned insulators on top of power poles. As a younger man, Fred had the job of wiping insulators. Once on a high tower, he dropped his cleaning rag. Rather than climbing all the way down for another, he took off his cap and put it to good use. Fred also built small wooden duck boats and served as Alviso's mayor in the 1930s. (FH)

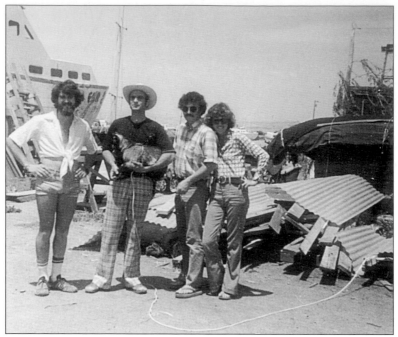

START OF THE BOATBUILDING COMMUNITY. In the 1960s and 1970s, "hippie" boat owners and builders took up residence on both sides of Alviso Slough. They were drawn to Alviso because of available space and low rents. While some found the accepting place perfect to build the boat of their dreams, others found that it took more time and money than imagined. Year after year, they worked on their mono- and multi-hull wooden, fiberglass and ferro-cement sailboats, and motorboats. Joined by owners or renters of existing boats, they created a hippie-style community of boat builders, house boaters, dreamers, drifters, and partiers. Accommodations ranged from former Alviso mayor Garland Oliver's comfortable 100-foot, wooden World War II submarine chaser, to Slough Doug's canoe, hidden in the reeds. There was even a small manufacturing concern that turned out cheaper winch handles marked "Made in Alviso by Hippies." (Courtesy Catherine Leeson.)

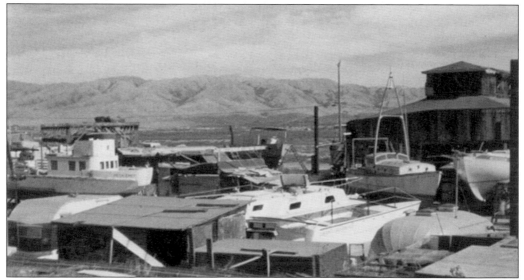

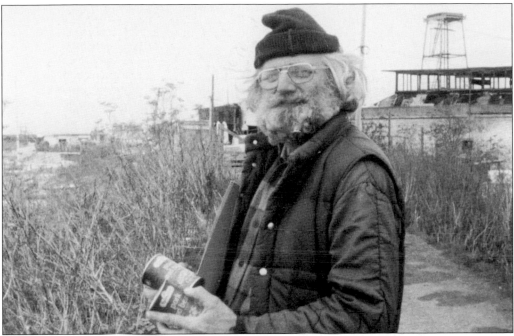

ELLIS CROSS, BOAT COMMUNITY POET, 1975. One unforgettable member of the boating community in the 1970s and 1980s was the local bard, Ellis Cross, the poet laureate of Alviso. Ellis had drifted west from Indiana with his faithful beagle Maximilian Rex, stumbled upon Alviso by accident, and found it agreeable. (Courtesy Catherine Leeson.)

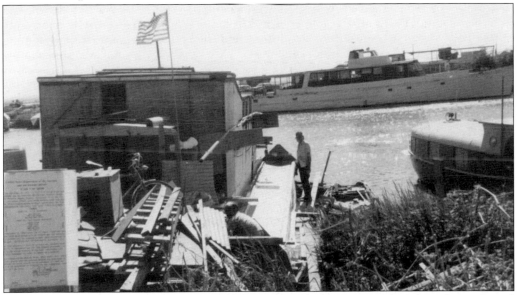

PORT ATTRACTS POETS AND ARTISTS. Ellis Cross found a boat to rent cheaply and stayed until it burned in 1985. He had to move ashore, eventually to the Yountville Veterans Home. His houseboat can be seen tied up on the west side of the slough in this 1978 photograph. Over the years, Alviso has beckoned to creative types inspired by its bohemian spirit and natural beauty, including photographer Minor White, painters O. J. Cook, Robert Wood, Patricia Buchser, and, recently, Bob Rockwood. (RB)

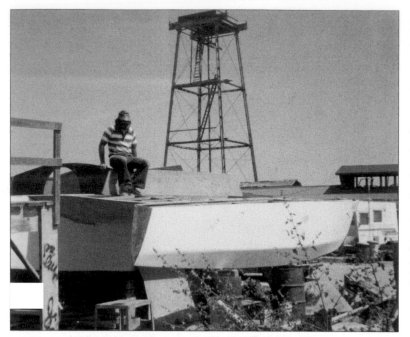

SKIP WAMSLEY BUILDING HIS TRIMARAN. Skip spent four years completing his 31-foot Jim Brown Searunner, the *Windspell*. Trimarans were a popular design for the Alviso Slough because of their shallow draft. The large tower in the background was part of Bayside Cannery, built by Thomas Foon. (Courtesy Catherine Leeson.)

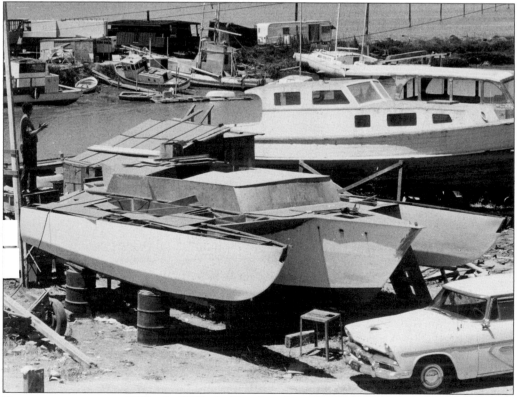

DREAMBOATS IN THE 1970s. In 1978, the *Bay Area Journal* called Alviso "a haven for deadbeat boat builders and rootless dreamless dreamers." It was a time for idealists and creativity outside the box—of different boats for different folks. (Courtesy Catherine Leeson.)

AIRBORNE LAUNCH IN 1978. One of the largest boats ever built on the slough was Rich Gallegher's 1970 three-level ferro-cement cruiser, the *Dionysus*. After several years of construction, it was launched in July of 1978 from a barge-mounted crane floated down from the north bay. The *Dionysus* was one of the last boats launched from Alviso Harbor. By 1993, the docks were completely cleared of those boats that had somehow survived from Alviso's shipping heyday over 100 years earlier. (Courtesy Catherine Leeson.)

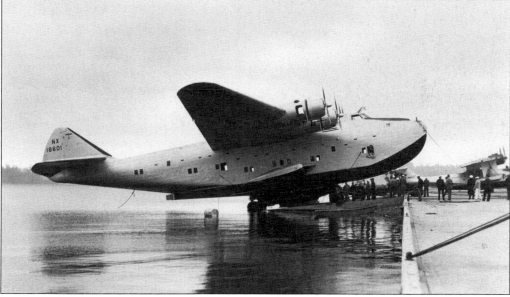

KAISER'S FLYING BOATS. Another of Alviso's unfulfilled dreams was Henry Kaiser's plan for a seaplane manufacturing plant in Alviso. Above is a China Clipper–type flying boat, popular in 1938. Much later, residents didn't want San Jose's airport to expand to Alviso; San Jose had already sent its waste, they did not want its noise. (FH)

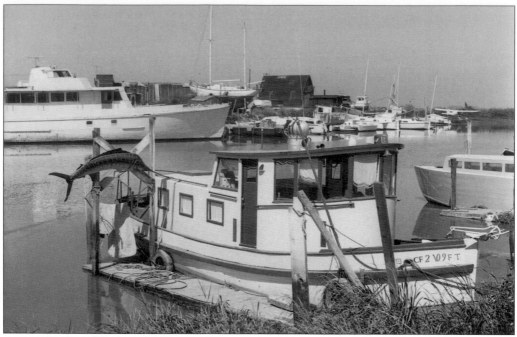

ALVISO SLOUGH LOOKING WEST. In the 1970s, boats lined Alviso Slough. Its banks were covered with boats in states of repair or construction and structures to live in—from shacks and trailers to the cathedral-shaped houseboat belonging to John Hawkins (back, center). The large white boat (left) was Mayor Garland Oliver's. His business card quoted the *Bhagavad Gita*: "Out of the mud grows the lotus." Fishing boats such as Mike Trojan's (front, center) were a common sight. Note the seaplane on the right. (RB)

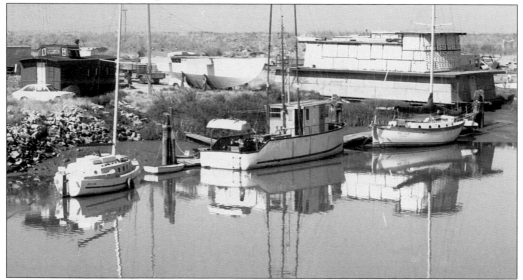

CABOOSE KEEPS BOATS AFLOAT. The 1890 caboose (back left) was used as a workshop for boat materials. Sailboats and a fishing boat are tied up on the west side of the slough in this photograph, c. 1978. Clyde Robson worked for years to convert the 360-ton ferry, in the background, into a hospital ship to serve coastal Indians in Canada. Still incomplete in 1993, it would be moved when the yard it was sitting on was cleared for environmental concerns. (RB)

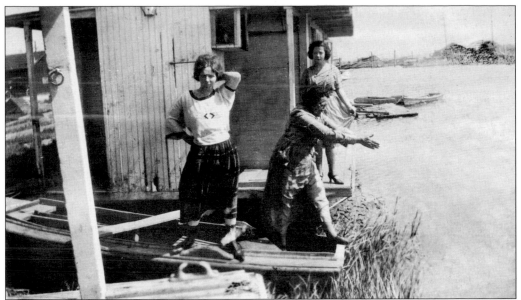

LADIES OF THE SLOUGH. These free-spirited women flaunting their outfits on a houseboat suggest the do-it-yourself attitude that characterized Alviso and especially Drawbridge. It was not a place for the materialistic. There were rumors of fast-living ladies of the night out there and other edgy types who would do their own thing in holes-in-the-wall on the bad side of town. (Courtesy Maritime Museum.)

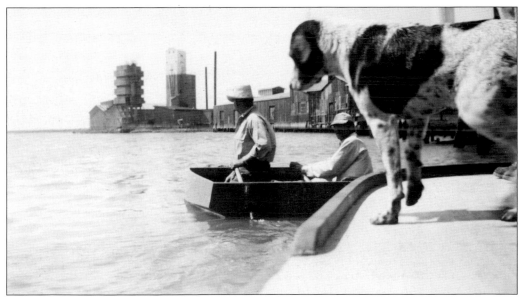

SCULLING NEAR SUNSET DISTILLERY. The distillery in the distance used fermenting peach and pear juice to make neutral spirits and "torpedo juice" in World War II. Trucked to Alviso in tanks that popped their lids on the way, the juice was poured into huge vats. Fred Huxham IV (right) invented this "double sculling" boat. His hunting dog Soupy stands by. (FH)

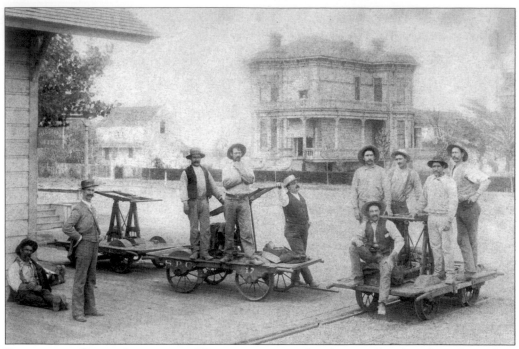

PORTUGUESE TRACK CREW, 1890. These narrow-gauge handcars used at the Alviso depot (left) were an important part of the South Pacific Coast Railroad. The Victorian Tilden house stands in the background on Elizabeth, left of the Tilden Store. (TL)

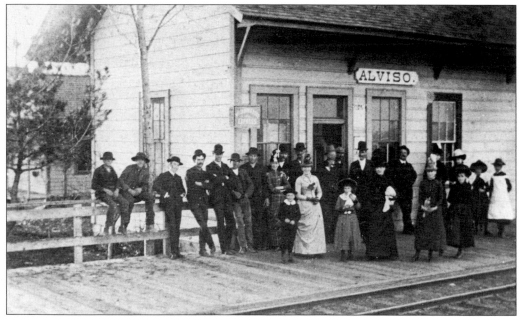

WAITING FOR THE TRAIN, 1890. From left to right are Octave LaMontagne, Frank Berryessa, Jim Martin, John Anderson, John Lords, Aleck Berryessa, Fred La Montagne, Mrs. N. Pitman, Mr. N. Pitman, Theodore Martin, William Miller, Miss Mary Ann Martin, Richard Kehl, Miss Esther Martin, John Martin Jr., Miss Pitman, Charles Bradley, Maggie Martin, Nellie Gwin, Susie Gwin, Flora Martin, Rebecca Berryessa, and Minnie Berryessa. (Courtesy Sourisseau Academy.)

Four

THE RAILROAD
CORRIDOR

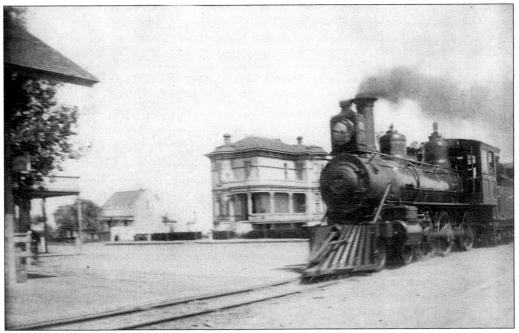

TRAIN ENTERING ALVISO, 1900. This narrow-gauge "Ten Wheeler" (4-6-0) crosses Elizabeth Street, with the depot on the left. In 1880, the San Francisco–San Jose railroad bypassed Alviso, a blow to the port. Then "Sunny Jim" Fair ran a narrow-gauge track between the other lines, right across the slough, to Santa Cruz. By 1884, when the first South Pacific Coast Railroad train rolled across the marshlands, customers had high-speed passenger service from San Francisco to Santa Cruz, via Alviso. The trip, including the ferry ride to Alameda, took just under four hours. When shiny silver and black locomotives whistled over Station Island trestles and bridges, a duck-hunter's community grew up at Drawbridge. After Southern Pacific purchased South Pacific Coast Railroad in 1888, a spur to Lick Mill and service to Agnew's state hospital were added. Scheduled for standard gauge on April 18, 1906, plans were smashed by the earthquake. The north end of the line reopened in weeks, but the south end wouldn't reopen until May 1909. The 6,023-foot summit tunnel had been sheared in half at the San Andreas Fault. During World War II, remaining mountain tunnels near Wright's Station were sealed. Much of the line past Alviso survives as part of Union Pacific Railroad that sends six trains along this historic corridor daily. (TL)

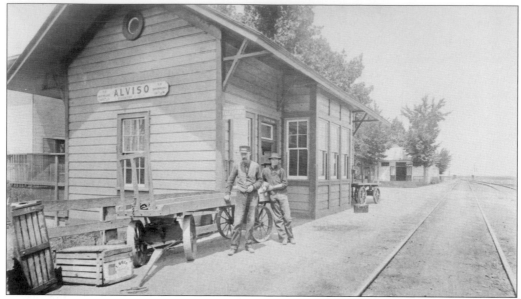

ALVISO DEPOT, 1910. When Southern Pacific took over, the new sign read "To New Orleans 2, 436 4/10 Miles, Alviso Elevation 11', San Francisco 39 1/10 Miles." The depot was remodeled with an extended roof and bay ticket window. The wooden deck was removed and a larger standard gauge track (four feet by eight-and-a-half inches) replaced the three-foot gauge. The station attendant then was Charles Bradley. (Courtesy William Wulf.)

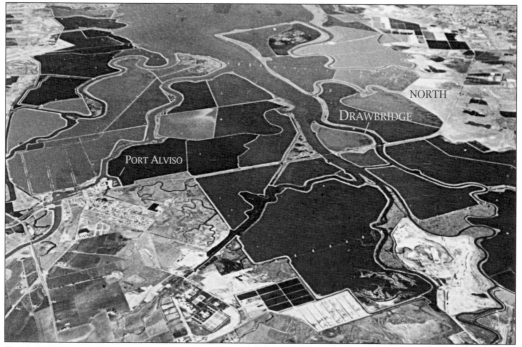

AERIAL VIEW OF DRAWBRIDGE, 1980. Drawbridge, California began as a marshland train stop at the end of the San Francisco Bay. Only seven-eighths of a mile long and 80 acres in size, it rose and fell with the tides over a period of 100 years. Boats carrying produce for San Francisco passed under train bridges swinging out to let them through. (DENWR)

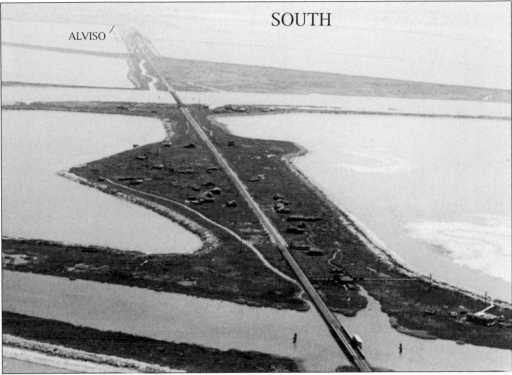

ALVISO

A TOWN TIME FORGOT. Drawbridge grew from a two-room bridge tender's cabin in the middle of Station Island, to a vacationer's paradise popular for duck hunting and swimming in the sloughs, and finally to a lawless ghost town. All that remains are tales of sunken trains, ladies of the evening, and paradise lost; after salt developers, groundwater pumping, and sewage backup sank Drawbridge into mists of memory and legend. (DENWR)

ENTERING DRAWBRIDGE FROM MUD SLOUGH, 1930. This southern-facing view reveals many flags displayed the Fourth of July. The two rails in the middle are derail guards, used to prevent trains from falling off the trestle into the slough. (DENWR)

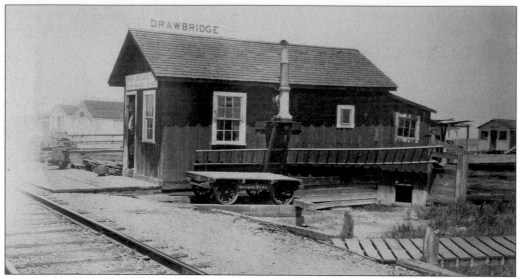

THE BRIDGE TENDER'S PLACE, 1912. This 8-by-12-foot wood-framed cabin sat halfway between the two swinging bridges. A traditional station never existed. Mr. Mundershietz was the first bridge tender, in 1880. Cabins on Station Island were built on stilts above the shifting tide. Floors were plain wood or linoleum; roofs were redwood shingle with seal oil to keep out the elements. Wooden walkways formed streets; Main Street was the railroad track; catwalks led to the cabins. (DENWR)

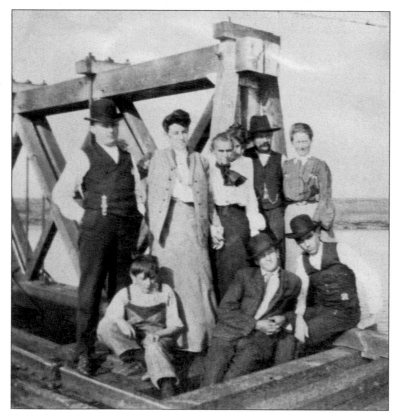

LONG FAMILY AT MUD SLOUGH BRIDGE, 1920. In 1876, heavy swing bridges were built of redwood timbers. Mr. Mundershietz invited friends to stay the night in his bridge-tender's cabin while they were out duck hunting. Soon, the Gordon Gun Club was built and cabins and shacks collected on both sides of the track. (DENWR)

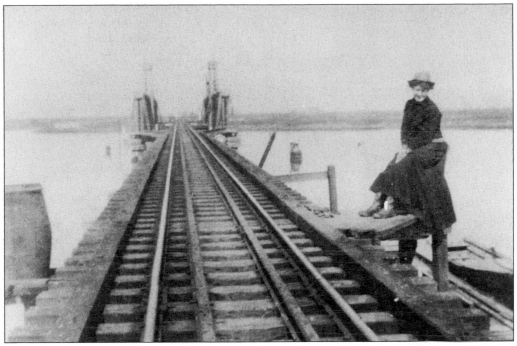

ENTERING DRAWBRIDGE, 1910. This view south over Coyote Slough shows the first of the two swing bridges, two-and-a-half miles from Alviso in the distance. Ann Byrnes, a longtime resident of Drawbridge, sits on one of two fire barrels placed by the railroad to put out sparks sprayed by steam locomotives. (DENWR)

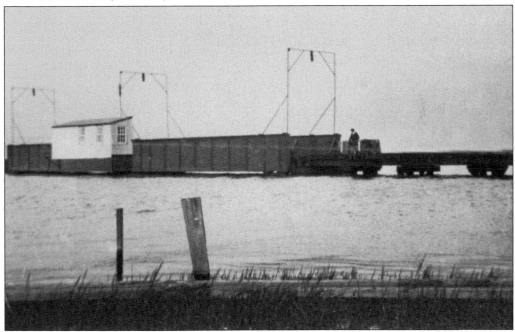

SWING BRIDGE OVER MUD SLOUGH, 1911. Built in 1904, the four-lever mechanical interlocking bridges included powered warning signals for two bridges at each end of Station Island. The bridges were retired in 1944 and replaced by two trestles in 1987. (DENWR)

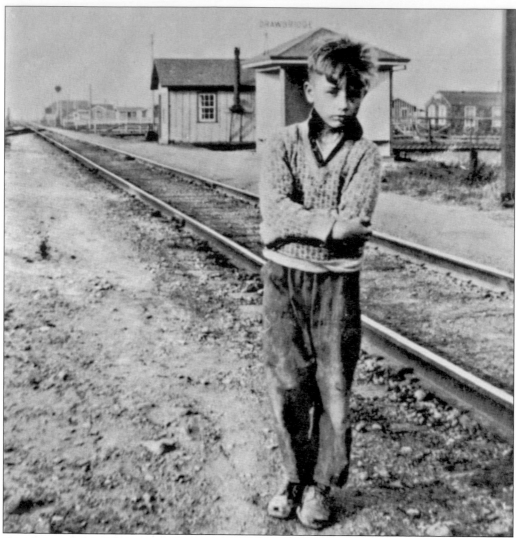

STANDING IN THE MIDDLE OF DRAWBRIDGE, 1930. School, for many of the children who lived in Drawbridge, was three miles down the track in Alviso. The "Greek Cross" passenger shelter behind Roger Dolan was Drawbridges' only depot. The Drawbridge sign was moved from the bridge-tender's cabin to the shelter shortly before this photograph was taken. (Courtesy San Francisco Bay Wildlife Refuge.)

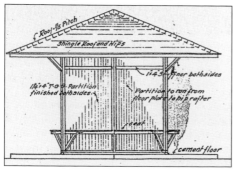

SHELTER SHED DRAWING NO. 1004. In the March, 1910 design, four walls crossed at 90 degrees and formed the back of the seats. The 10-by-10-foot wood shelter was built by the Southern Pacific Railroad Company in 1914, retired from the roster March 30, 1941, and destroyed in the 1970s. (Courtesy Henry Bender.)

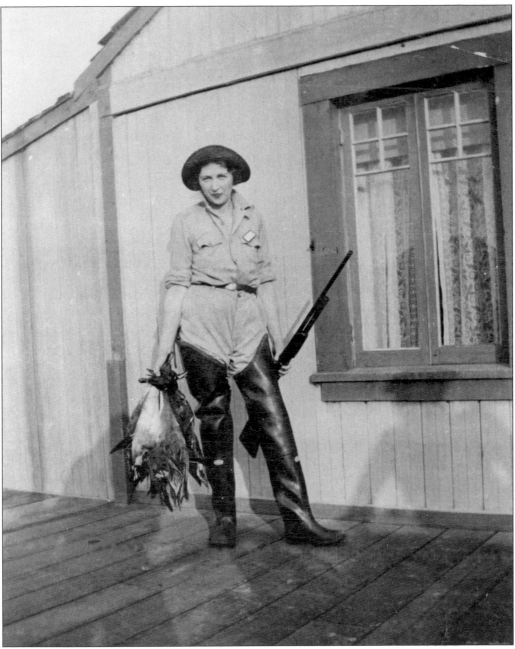

THE BELLE OF DRAWBRIDGE, 1920. Nellie Dollin visited her dentist father's cabin in 1910 and stayed around until 1974. She built her first house in 1932, married and divorced three times with three sons, but always came back to Drawbridge. Friends would row to her porch for "high-tide parties." The whole town of private cabins and duck clubs was built on pilings. By the 1970s, the train bridge had been replaced by a trestle; wildlife was reduced by sewage, and groundwater pumping was sinking the island. Salt pond levees cut down water flow, but the last holdouts stayed on, guns in hand, docking their boats at the front door. Vandals drove the beautiful Nellie Dollin away, and Charlie Luce gave up the ghost to the wildlife preserve. Twenty dilapidated cabins and a lot of stories remain for the marshes to reclaim. (DENWR)

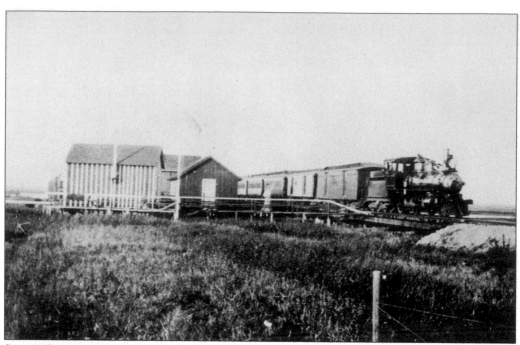

SOUTH PACIFIC COAST, 1890. A narrow-gauge train stops at the "The Recreation" building on this romantic island. By 1926, there were 90 cabins and five trains passing through Drawbridge daily. (DENWR)

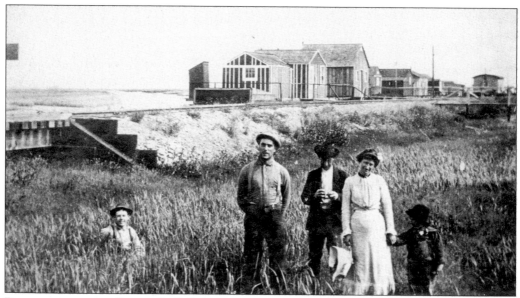

PICNICKERS IN THE REEDS. Irish, Italian, Portuguese, French, and Germans lived on the south side, and Protestants on the north. Overall it was a town of lasting friendships, independent spirits, and freedom. Some cabins were papered with burlap, others insulated with old newspaper printing plates—the beginning of "found art" and recycling. Flower boxes and other simple beauties abounded. (DENWR)

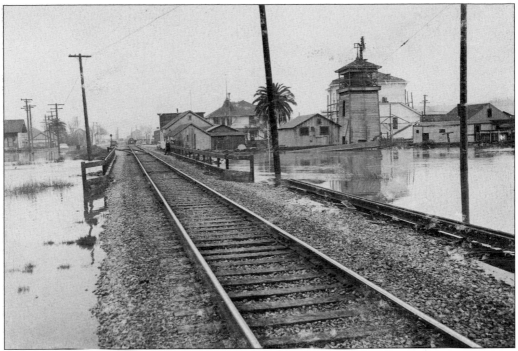

TRACKS HEADING SOUTH, 1930. Beyond the bridge (left) lies the Alviso Depot. To the right of the tracks are the Tilden-Laine Store, Alviso Hotel, and Tilden house barn and tankhouse. This area was the location for the 1949 Western *The Trouble at Melody Mesa*. (TL)

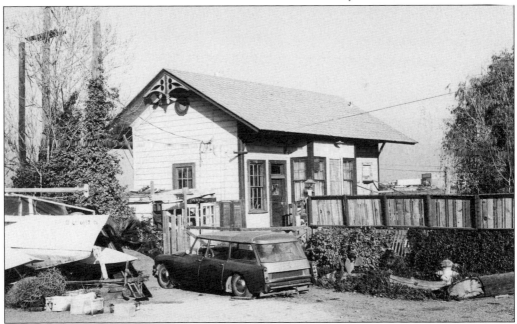

RELOCATED DEPOT, 1960. On November 2, 1938, Mayor Willis Laine bought the depot and moved it east across the tracks. Artist David Blaire rented the depot to make whirligigs. Like other Southern Pacific depots, the decorative eave sports an agricultural motif. Railroad fans keep their eye on this depot. (Courtesy Henry Bender.)

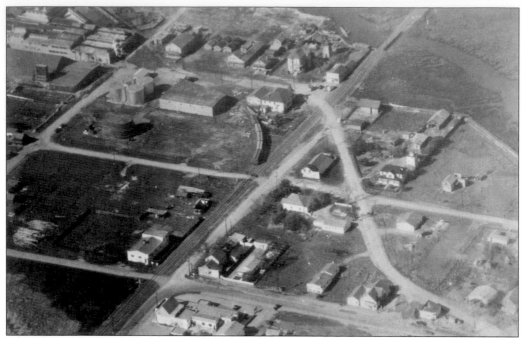

NORTH ALVISO, 1945. Elizabeth Street, Catherine Street, and State Street (North First Street), run horizontally (from top). Hope and El Dorado Streets run vertically (left to right). The diagonal road is the former Alviso-Milpitas Road coming west from Milpitas. Agriculture from Milpitas was brought over this road to Alviso. Jose Maria Alviso's rancho lay stretched from today's Alviso to Milpitas. Higher ground there prevented flooding. (Courtesy Joan Hoxie.)

MILPITAS-ALVISO ROAD, 2005. The Tilden-Laine house and store continue to stand as a reminder of the prosperous days when the South Pacific Coast first built this line into Alviso in 1876. (RB)

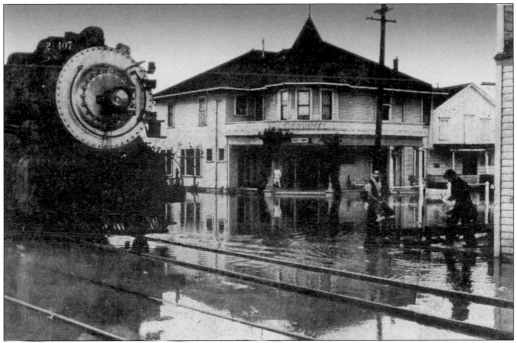

LOCOMOTIVE CROSSING ELIZABETH STREET, 1940. The *Mercury Herald* described this image like so: "A freight train locomotive creeps along over tracks inundated in most of the town but not yet in this particular spot. In the background, across the 'lake' is the entrance to Jack Ackerman's Alviso hotel." Popular with duck hunters, the hotel was featured in Westerns shot in Alviso. (Courtesy *San Jose Mercury Herald*.)

LIFE ALONGSIDE THE TRACKS. Depression-era folk stand in front of an early cannery house with a Model A in the background. (TL)

AN ILLUSTRIOUS ALVISO FAMILY. Pictured, from left to right, are attorney Walter Chisolm, Carrie Davee Chisholm, their son Herbert Chisholm (who later managed Blake, Moffitt, and Towne Paper Company in San Jose), Belle Davee, Alviso postmistress from 1916 to 1940, Nadine Workman (who later married Dr. Calcagno of San Jose), Irene Davee Workman, Frank Workman, Alice Davee Huxham, Fred Huxham IV, and their son Fred Huxham V (later driver for Sunset Distillery, Palo Alto bookstore owner, teacher, and Alviso artist—see his painting on the opposite page.) (FH)

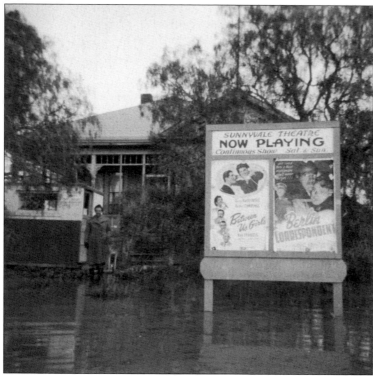

POST OFFICE AND LIBRARY. Alice Huxham stands between her house and the shed that housed the post office and Santa Clara Free Library she ran for a salary of $5 a month. Here residents getting mail could see what was playing at the Sunnyvale Theatre, even when floodwater encroached. To this day, Alviso remains a separate zip code and residents pick up their mail. (FH)

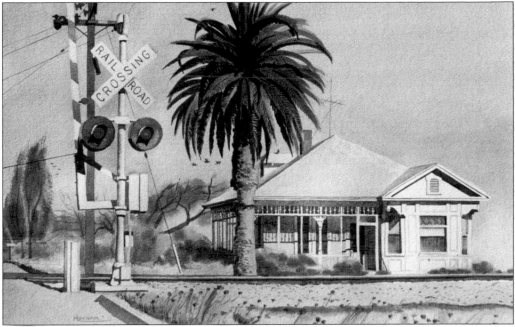

TREVEY-HUXHAM RESIDENCE. Fred Huxham painted this watercolor. Like his mother and grandmother, Fred is an Alviso native. His parents first rented this house for $15 a month, then bought it in 1942 for $2,200. He has fond memories of a "very good childhood" with the sounds of the trains passing by and the sight of hobos riding on top of sugar beets, throwing some to the kids. He learned "old Civil War songs" at Alviso's diverse, friendly school. (FH)

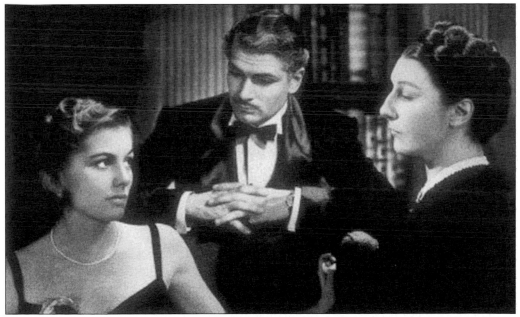

JOAN FONTAINE IN ALVISO. One of Fred's favorite memories is of waving to actress Joan Fontaine, who'd come from Saratoga to Alviso to inspire the Camp Fire Girls. Joan (pictured here in a scene from *Rebecca*, opposite Sir Lawrence Olivier) assisted Amy Coe at the church on State and Archer Streets in Alviso. What a thrill when Joan waved back. (FH)

Stagecoach across a New Bridge, 1936. The Wade stagecoach was purchased by Wells Fargo in 1928 for $500 and clattered over the Bay Bridge on opening day. It once took Chinese workers from San Jose to Alviso and back for 10¢ a ride. Henry Wade and his son-in-law Captain Ortley ran coastal ships, wagon, and stagecoach enterprises between San Jose and San Francisco. The stagecoach route from Alviso to Monterey (1880–1882) never took off. (Courtesy Wells Fargo.)

Henry Wade's Wagons, c.1890. The Wade family escaped Death Valley in 1849. Drawn to water-bound Alviso, they distinguished themselves. Harry George transported lumber with his father, built a wharf warehouse, and was justice of the peace (1880); son Charley married Estefano Alviso and received 500 rancho acres for strawberries, onions, raspberries, hay, and grain; son Richard Wade (whose second wife was Maria Berryessa) drove Lick's team. Mary Ann married Alviso railroad agent Bradley; Almira married Captain Ortley and kept the warehouse books. (Courtesy Sourisseau Academy.)

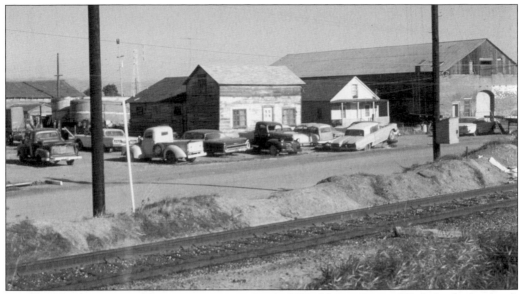

WADE RESIDENCE AND WAREHOUSE, C. 1868. In 1850, Henry George Wade built this brick warehouse on his waterfront wharf. By 1888, steamers brought coal for the Agnew asylum and returned with baled hay and grain sacks to feed city horses. Most everything passed through the Wade family warehouse. During the late 1960s, Margaret Higgins Wade lived alone in the house; in her nineties, she still baked cakes on the wood stove in her grandfather's kitchen. (Courtesy De Anza College.)

OLD WADE HOME, ALVISO, C. 1891. This prefabricated house bought by the late Henry G. Wade is one of many shipped around the horn in the early 1850s. It is an Alviso landmark. Wade's granddaughters, Annie and Margaret, stand in front of the hitching rack. Margaret was queen of Alviso (1883) and later directed the state asylum. Fr. Jonathan Wade teaches at Bellarmine in Santa Clara. (Courtesy Sourisseau Academy.)

KNIGHTS OF THE ROAD. In 1939, the railroad hobos found refuge near the track "about a mile south of Alviso on the Santa Clara Alviso Road an old, old house" (*Mercury Herald*). Wisps of smoke could be seen coming from "rat haven," as the abandoned Gallagher house on the Embarcadero grant was called. In 1831, Gallagher came to Alviso. He built the first canvas warehouse on the dock, married Maria Remonda (Ortega), and ran Gallagher Fruit Company near First Street. He later let "Chinese" stay at the house. During the Depression, Irishmen like James Duffy, who told the tale to the paper, and fellow railroad bums found it a haven every night. Old clothes, books, and magazines were stuffed into the walls. A nautical rope contraption hung from the ceiling, suspending frying pans above rats living under the floor. (Courtesy Alviso Library.)

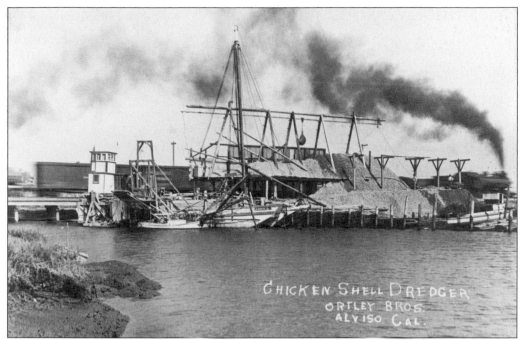

ORTLEY BROTHERS' CHICKEN SHELL DREDGING. Oysters were one of the main industries in Alviso before its waters were polluted. The Ortley Brothers dredged and collected oyster shells that were pulverized for chicken food and fertilizer. These were shipped to Petaluma, a poultry center by barge, and later also by train. (Courtesy Alviso Library.)

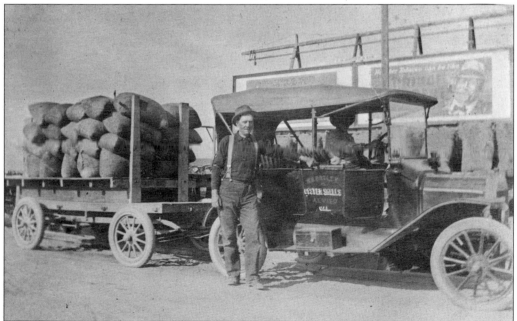

OYSTER SHELLS FOR SALE. The early Model T is filled with bags of shells from this Alviso business on the southern fringes of town. The chicken shell operation stood at the junction of the old Guadalupe River, the Alviso Slough, and the Southern Pacific Company trestle. From here, shipments were delivered by the touring car, or by rail or boat. (TL)

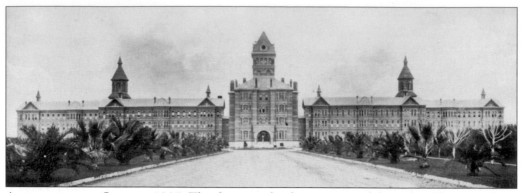

ASYLUM FOR THE INSANE, 1888. This four-story brick structure with barred windows stood one block southeast of Agnew Depot. Built to alleviate overcrowding at Stockton, it had a 274-acre farm, employed 100 people, and, by 1906, housed 1,073 patients. It had a big administrative wing. Superintendent Leonard Stocking's dream of humane treatment fell apart in the 1930s. By the 1970s, the "developmentally delayed" replaced the mentally ill; the Lanterman Act helped many find community group homes. (Courtesy William Wulf.)

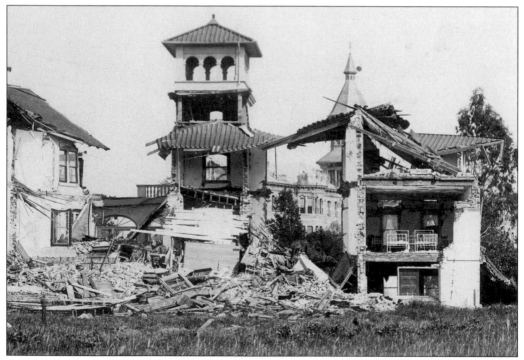

ASYLUM RUINS OF 1906. State patients were tragic victims of the April 18th earthquake, with 275 dead and hundreds treated. Agnew lay in a mess of ruins; its brick buildings were not reinforced. The greatest numbers of fatalities in the San Jose area were recorded at the asylum. Here two beds lie (right) where the wall fell away. One inmate, Dr. Cornow, "of this city," recovered his sanity from the shock and aided the only other doctor left. (Courtesy William Wulf.)

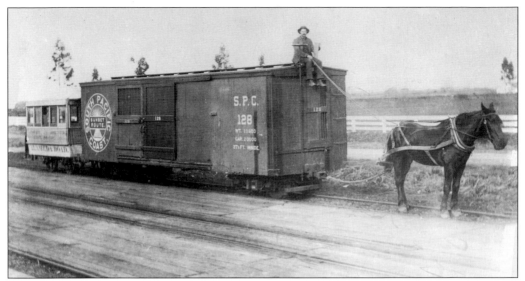

SIDING TO AGNEW/LICK MILL, 1887. Tracks led from Alviso two miles to the new Lick Paper Mill. The next year the hospital would be built on Lick's property and got its coal from the Wade Warehouse. A horse pulled cars along the siding. The boxcar has vented doors for transporting strawberries, produce, and wheat from farmers like Frank Bray, the Wades, and Lick. The horse car (left) was used to transport workers. (Courtesy William Wulf.)

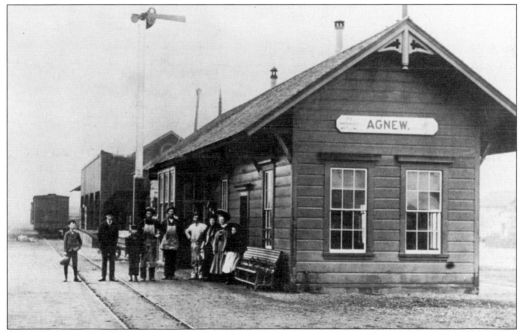

AGNEW DEPOT, C. 1890. The right side of the Agnew sign read "40 6/10 Miles to San Francisco." The depot was less than two miles to Port Alviso, half a block to the Lick Paper Mill, and a block to the Agnew Store and hospital. Station Agent Fuller photographed classic scenes like this. Notice the chili-pepper design near the apex of the roof. (Courtesy William Wulf.)

JAMES LICK, (1796–1876). This visionary speculator shaped the Alviso District and much of California. He built his mill home on the Alviso farm, where he slept on a door supported by wine barrels in his mansion's kitchen. Compelled by loneliness, Lick had an urge to build. At 12, the Pennsylvania-Dutch son of a woodworker lost his mother, who loved to garden. As a young man, he fell in love with Barbara Snavely, daughter of a local miller. When she became pregnant, her father refused to let Lick marry her. "When you have a mill as large and costly as mine you can have my daughter's hand—but not before." Lick fled to South America and crafted wood for pianos. A priest felt sorry for the solitary man and talked to him about adding to the universe. Thirty years later, when California was about to become a state, Lick sensed opportunity. He'd use his Spanish and buy up as much land as he could. Wounded and alone, dressed in ill-fitting clothes, James Lick would come to define prosperity itself. (Courtesy San Francisco Public Library.)

Five

The James Lick Legacy

Lick Mill and Granary, 1852. The mill became known as "Lick's Folly" because he used expensive machinery and exotic polished woods. Though it burned in 1857, its "rat-proof" granary remains a model of circular brick masonry. James Lick had arrived in San Francisco 17 days before gold was discovered on January 7, 1848, with an iron strong box containing $30,000 in cash, and 600 pounds of chocolate he'd brought from his friend Dominico Ghirardelli to seal the deals. With a keen sense for investment, Lick bought up land just before the San Francisco boom. Two years later, he was one of the richest men in California. He secured his mill farm on Ygnacio Alviso's grant by the Guadalupe River and shipped tons of wheat from Port Alviso. His holdings throughout the state included the famous Lick House in San Francisco and Catalina Island. This legend in his own time found most people ridiculous and preferred the company of his plants. As he advanced in age and prosperity, the "Generous Miser," turned his thoughts to spiritualism and the beneficent use of his wealth. Lick died in 1876, three years after a stroke that prompted him to bequeath $3 million to California's future. (Courtesy History San Jose.)

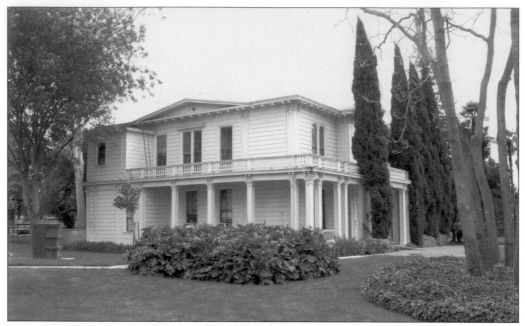

JAMES LICK MANSION. In 1855, Lick's illegitimate son, John, came west with the news that Barbara Snavely, his mother, had died in 1851. Lick crafted this Italianate-style villa in 1860 to bring his family together. He pioneered fruit-drying techniques on the grounds and brought plums inside and laid them on newspapers. He predicted that Santa Clara Valley would become the world's greatest prune center. When Lick's son could no longer stand his father's directives and Spartan life, he lived in Port Alviso before returning east in 1863. (RB)

LICK'S DREAM FULFILLED. According to Janet Childs of the Centre For Living With Dying, the Lick Mansion was built adjacent to sacred Ohlone burial grounds. After Lick's passing, the mansion was bequeathed to the community and used by groups like Lick's orphanage and the San Jose Benevolence Society. Recent groups include UCM churches and the center that debriefed first responders in the 9/11 tragedy. Lick's house became a place for those who've known loss and trauma, to safely grieve. Pictured, from left to right, are Janet Childs, Doti Boone, and Lynn Rogers, who lead community celebrations at the mansion. (RB)

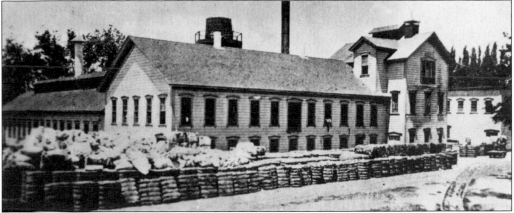

LICK PAPER MILL EXTERIOR, 1896. When he became ill in 1873, Lick sold the flourmill to Adolph Pfister who converted it to a paper mill using Santa Cruz lumber. In 1878, A. D. Remington found that fruit shipped better wrapped in paper. Lick Mill became one of the largest paper mills in the West. It burned in 1882 and was replaced without Lick's mahogany interior. Inlaid carpentry designs visible in the rooftops and windows mimicked Renaissance motifs. The mill ran night and day. (Courtesy History San Jose.)

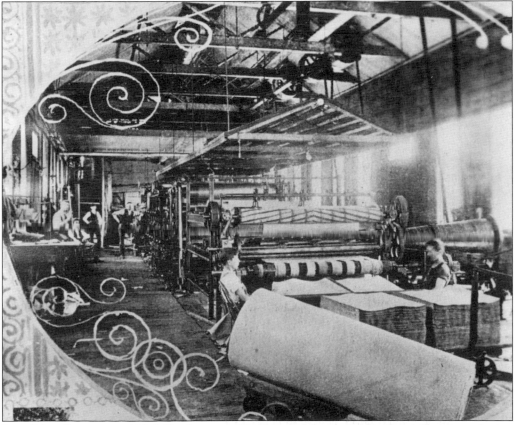

LICK MILL INTERIOR, 1896. By the time this photograph was taken, the mill was producing paper. The Sanborn Fire Map offers an inside look at the mill. The notation lists 40 employees working at the Lick Mill, but "no Chinese." (Courtesy History San Jose.)

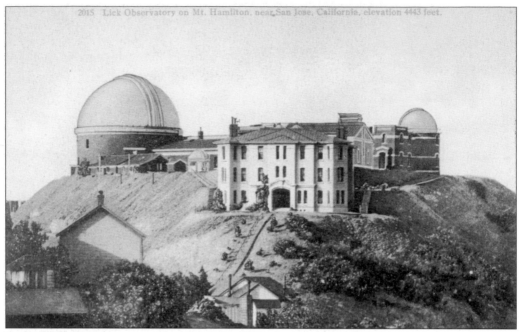

JAMES LICK OBSERVATORY, SAN JOSE. In 1875, observatory builder Thomas Fraser chose Mt. Hamilton at 4,448 feet, because "Lick could see it from his mill at Alviso." Willed to construction after Lick's passing, it was completed in 1888. Acquired by the University of California that year, it housed the world's largest telescope used in the early mapping of the universe. The first of three observatories became Lick's final resting spot, a testimony to California's first philanthropist. (Courtesy Darrell Severinsen.)

JAMES LICK BRONZE. This monument marks the entrance to the James Lick Observatory. His legacy includes James Lick High School, the Lick Baths, the Lick Wilmerding School, the Lick Old Ladies' Home, the Society of California Pioneers, the California Academy of Sciences, organizations preventing cruelty to animals, and the San Jose Orphan Asylum. Lick's Mansion and Brick Granary are listed in the National Register of Historic Places. (Courtesy Darrell Severinsen.)

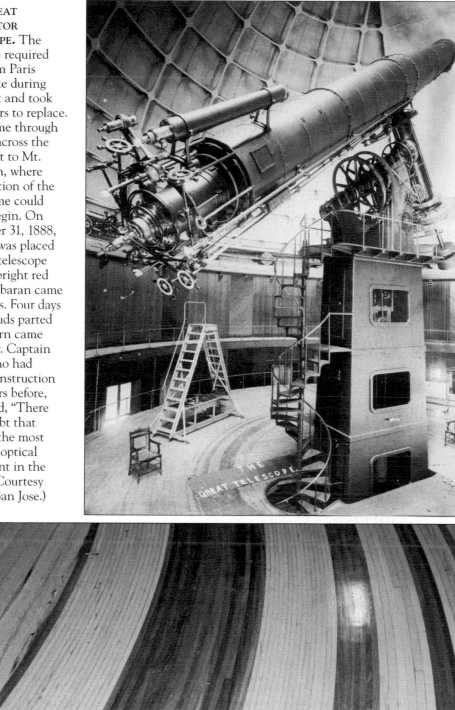

THE GREAT REFRACTOR TELESCOPE. The telescope required discs from Paris that broke during shipment and took eight years to replace. They came through Boston, across the continent to Mt. Hamilton, where construction of the great dome could finally begin. On December 31, 1888, the lens was placed into the telescope and the bright red star Aldebaran came into focus. Four days later, clouds parted and Saturn came into view. Captain Floyd, who had begun construction eight years before, exclaimed, "There is no doubt that we have the most powerful optical instrument in the world." (Courtesy History San Jose.)

HOMAGE TO JAMES LICK. Lick was a master woodworker. He was buried under this wooden floor at the foot of the telescope. When a long-overdue cleaning procedure was recently completed, telescope operator Darrell Severinsen was astonished to see the celestial motif. Orbital rings are suggested by the floor design. The Lick moon crater and asteroid were named in 1951. (RB)

ROWING ON LICK'S POND. After Lick's passing, the people of the Agnew, Alviso, and San Jose areas enjoyed the mansion grounds, rowing on the millpond or exploring the house. The buildings and grounds were open to the public as a park under the terms of his bequest. Ironic that Lick who bequeathed them for families to enjoy had no family himself and was presumably apart from female company. (Courtesy Darrell Severinsen.)

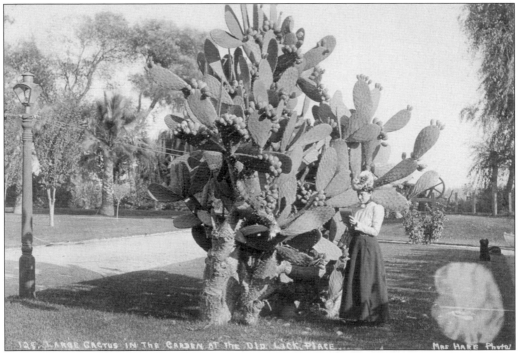

LICK'S EXOTIC TREES. This sightseer in Victorian attire studies printed material on this species. Lick imported many exotic trees from Peru; these cacti are an example, the cork oaks around the mansion, another. He left a nursery on his grounds, and another in San Jose on Willow Street. Lick was exacting; he once tested a worker's capability by insisting that he plant some upside down—to see if the man would follow orders. (Courtesy Darrell Severinsen.)

90

Six

FIELDS, FARMS, AND FLOODS

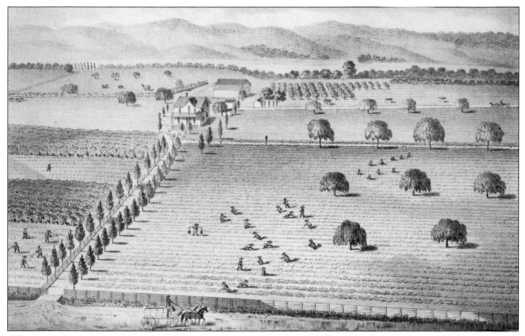

WORLD'S LARGEST STRAWBERRY RANCH, 1877. According to the *San Jose Daily Mercury*, Charles Wade held the largest strawberry ranch in the world. When the Strawberry Growers Association was founded in Santa Clara County, its headquarters was in Alviso. Until the 1980s, fog permeated the South Bay. Humus-rich soil mingled with the evening air to create low-hanging tule fog. In 1792, Spaniards introduced prunes to California, and according to Gen. Mariano Vallejo's daughter Ruy Kern in 1880, the mission orchards grew apples, pears, apricots, plums, plantains, bananas, and citrons. With American and European farmers pouring into California after the gold rush, by the 1870s, vast orchards stretched as far as the eye could see, with fragrant blossoms and sweet fruit in an endless sea. It took Thomas Foon's cannery in Alviso, and farmworkers from many cultures to keep up with the crops. Instead of relying on the Guadalupe River's periodic flooding, growers tapped artesian wells. When these dried up, farmers pumped groundwater, sinking the valley, especially the south end. Alviso was the bottom of the well, the broken heart of the once beautiful valley. By the 1980s, asphalt and business parks had paved over the orchards, drying up the fog that once moistened the strawberry fields of Alviso. (Courtesy Thompson & West, 1876.)

JOHN ROCK. Born in Germany in 1836, Johan Fels immigrated to America and used the English translation of his name, John Rock. He had loved plants since childhood and worked as a florist and in nurseries. With only a few years of formal schooling, he spoke five languages fluently. Serving in the 5th New York Infantry during the Civil War, he knew Abraham Lincoln and was one his pallbearers. Afterwards he came to California and worked for James Lick. He saved for his own nursery, crossed wild plum with prune trees, and won international recognition for plant propagation. Luther Burbank said, "John Rock is the most learned man in his profession to be found in California." (Courtesy Nelson Kirk.)

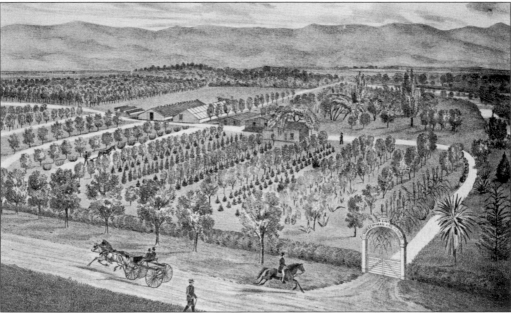

B. S. FOX NURSERY, 1876. In 1863, John Rock moved to California. In 1865, he started a nursery just south of Alviso. In 1879, he secured a new location (pictured above) five miles southeast along the Coyote Creek near Wayne Station. Twenty years later, he merged his business with R. D. Fox, creating the California Nursery Company. (Courtesy Leonard McKay and Thompson & West, 1876.)

PRUNE BRANDY FOR PASSOVER. Rabbi Mayer Hirsch and his assistant Rabbi Hyman Posner brought revenue to Alviso by bottling prune brandy for Passover in the late 1820s and early 1830s. The prune pit was left in, and the brandy was bottled according to religious law. In four years, they bottled 1,800 casks containing 50 gallons of Slivovitz. In alcohol taxes alone, these represented $180,000 to the lowland hamlet of Alviso. (Courtesy Alviso Library.)

The PRUNE
a Justification for its Existence

by
Henry Louis Walsh
University of Santa Clara

ALICE HUXHAM IN ORCHARD. Orchards flowered around Alviso. In 1854, the French introduced their prunes here. In 1870, there were 19,000 prune trees in California. By 1880, large-scale orchards had been planted around the prune trees with apricots—the real California gold—and peaches added in. In 1886, John Rock imported the ultimate Clairac Mammoth prune tree. Alviso has always been a mixture of water and earth. (FH)

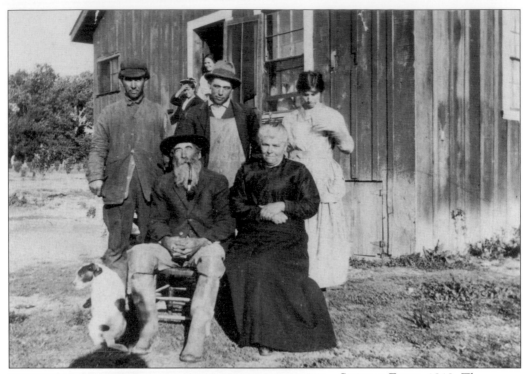

SILVERA FARM, 1918. The Silvera family had the pear orchard on the Alviso-Milpitas Road. Standing, from left to right, are Uncle Mike, Uncle George, and Aunt Mary Silvera. Seated are Victor and Marie Nunes Silvera. (Courtesy Weenie Thomas.)

WORKING THE PEAR ORCHARD, 1940. Pictured from left to right, are Helen Botello, Weenie Silvera, unidentified, and Andy Bereta sorting pears on Alviso's Lord Ranch. They transported their produce by trucks to Flotill Products Oakland, founded in Stockton, by a woman canner, Tillie Lewis. From 1895, three seed companies including C. C. Morris also grew onions seeds on 1,700 acres, with 300 workers a half mile from Alviso (Courtesy Weenie Thomas.)

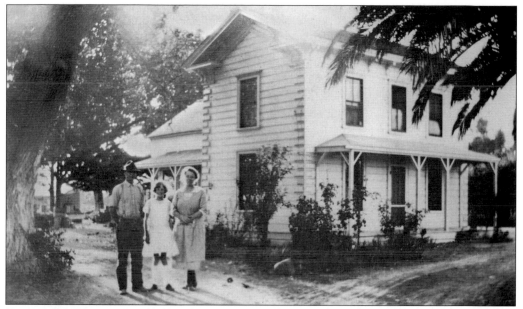

ZANKER HOUSE, 1918. Adolf and Emily Zanker stand outside their farmhouse with daughter Ethel. Adolf's grandfather came by wagon to his farm, disputed by Peter Burnett. Adolf's father, William, served as Alviso School trustee. Artesian wells bubbled up and irrigated their orchards. Decades later, sewage clogged Artesian Slough running by the Zanker property. In 1957, they sold the house to the waste plant. On September 14, 1986, it arrived at historic Kelly Park. (Courtesy History San Jose.)

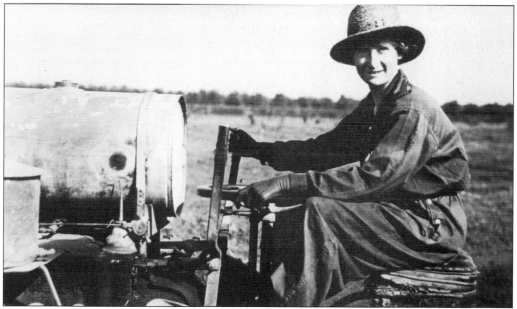

WORKING THE FARM, WORLD WAR I. When her brother Walter Brown was fighting in Europe and sister Ella Brown was serving the Red Cross ambulance core there, Edith Brown helped maintain the Brown family pear orchards. A white oak tree on their property marked the southeast corner of the Ulistec grant. Their father, George Brown, had come to the region in 1866 and shipped strawberries through Port Alviso. Edith created hybrid delphiniums. (Courtesy Lois Brown.)

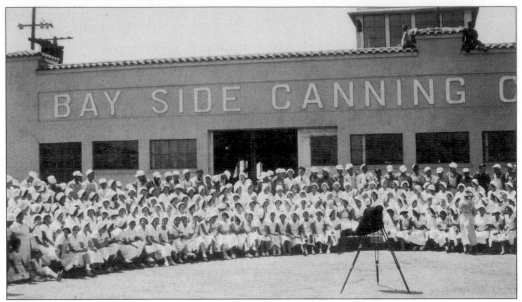

BAYSIDE CANNING COMPANY IN ALVISO. In 1890, Sai Yen-Chew founded Precita Cannery in San Francisco. After the 1906 quake and fire, Chew moved the cannery to Alviso, reorganized it as Bayside Cannery, and eventually bought the old Alviso Watch Factory. Chew built warehouses and boardinghouses for 100 Chinese laborers, where a room and three meals a day cost $2.50 a week during fruit-canning season. Other workers commuted in crude hard-tire buses from Santa Clara, Sunnyvale, Mountain View, and Milpitas. Without unions, mostly women workers toiled from 6:00 a.m. until products were processed, working Sundays. Bayside paid 25¢ an hour (a fair rate then), with no overtime. It paid piecemeal for stemming, cutting and coring cherries, peaches, and pears by the lug box. (TL)

PORTUGUESE CANNERY WORKERS, 1925. Mary Neves Pereira and Mary Azevedo pose at the Bayside Cannery. Foon Chew's granddaughter, Gloria Hom, states "Though the first cannery workers were 6,000 Chinese, others of Italian, Portuguese and 'Hindu' ancestry followed." He protected his business by building a levy to avoid flooding. He protected his workers by giving them IOUs for all but necessary expenses to keep them away from two local gambling houses. Five years after his passing, his fortune was depleted. His Alviso buildings include the Otis House—now the "Pickle Factory," the main cannery—now the "Boat Motel," and the cookhouse—now the "Art Gallery." (Courtesy Nadine Nunes Powers.)

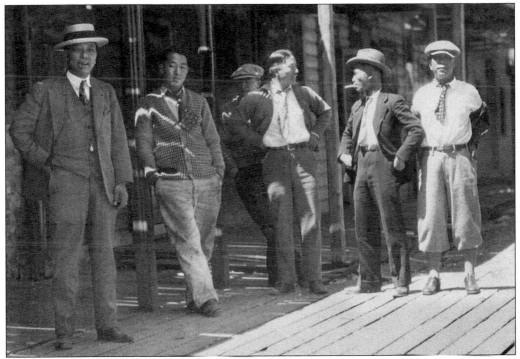

LEGENDARY BOSS. Thomas Foon Chew grew up in Alviso but went to school in San Francisco because "Orientals" weren't allowed at Caucasian schools. At 17, he joined his father at the cannery. His progressive ideas, intuition, and good decisions made Bayside the nation's third-largest cannery. His innovations included ketchup to save spoiling tomatoes, machine-washing sticky tomato boxes, turning hauling trucks into workers' buses and back again, and placing delicate green asparagus in cans. That earned him the title "The Asparagus King." His expanding canneries (also at Mayfield and on the Delta) relied on tugboats and barges. He planted peach orchards and shared well water with all in need. He was the first Chinese American to join the Masons. In 1931, when he passed at 42, Foon Chew was the wealthiest Chinese American in California. A crowd of 25,000 attended his funeral. Former mayor Tom Laine declares, "For decades, Thomas Foon was Alviso." (Courtesy Gloria Chew Hom.)

BAYSIDE CANNERY CANNING LABEL. This one features "Fruits for Salads." The cannery closed in 1936 but remains a source of pride for the town today. (Courtesy William Wulf.)

THE FOON CHEW CHILDREN, 1918. Pictured, from left to right, are Lonnie Chew, born 1911; Henry Chew, born 1918; Charlie Chew, born 1909; and Taidy Chew, born in 1913. Today Thomas Foon Chew Way (crossing Zanker Road by the power plant) brings honor to his descendents. (FH)

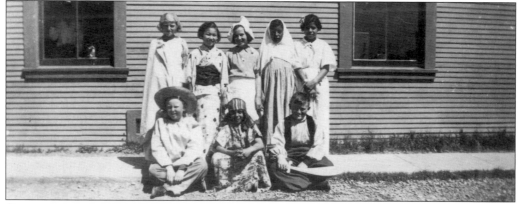

CHILDREN FROM MANY LANDS. Farm work brought diverse families to Alviso. Here Alviso children celebrated "International Day" by dressing in costume. Lifelong friendships formed. From left to right (seated) are Billy Zanker, Louis Gonzales, and Fred Huxham V; (standing) Shirley Chisholm, Asaye Mizota, Marie Ramirez, Maggie Posada, and Esther Gonzales. It was a heartache for the Huxhams when the Mizotas were taken from their First Street ranch to Japanese internment camps. (FH)

INTERNED MOTHER, C. 1946. Back from internment at Hart Mountain, Wyoming, Helen Mizota holds her baby in the Huxham's yard. The Mizotas were fortunate; friends in Alviso watched over their belongings and they were able to return to their ranch. Tommie Freddy Mizota lived in the Huxhams' attic while he signed up for the military. (FH)

EIDLEWEISS DAIRY DELIVERS. The independent Eidleweiss Dairy was named after a Swiss flower of quality and perfection. For decades, Eidleweiss Dairy lived up to the name. From 1938 to 1980, founder Frank Vogt and family kept hundreds of well-cared-for Holsteins in a shiny dairy with personal service. Its milkmen are missed today. (Courtesy Dan Vogt.)

GOVERNMENT FARMWORKER CAMP. Businesswoman Patty Hull-Anglin relates, "My Arkie parents lived in the Alviso labor camp in 1949 and 1950, picking cherries." When the Hulls lived there with baby daughter Janindal, later diagnosed with cerebral palsy, the floors were dirt, with no water or electricity. In 1949, Three Crown Movie Company of San Jose made *Trouble at Melody Mesa*, in Alviso. William Hull played a cowboy. The Hulls followed the crops, later settling in Linden. (Courtesy *San Jose News*.)

NEW LIFE FOR A PICKER'S CABIN. Migrant farmworkers lived in crude cabins and tents in the government camps in Alviso. They picked fruit from Morgan Hill to Sunnyvale. Here the mayor's Emergency Housing Committee has upgraded a shabby unit for evicted homeless. Gas, running water, electricity, sinks, painting, and wallpaper made Mr. and Mrs. Lester Corey's cabin a home. Daughter Lois cooks at a real stove. (Courtesy *San Jose News*.)

BRACERO ARRIVES IN ALVISO, 1943.
The first braceros (like this legally admitted Mexican laborer) arrived in Alviso to fill wartime shortages and harvest the huge crops. Baceros continued coming after the war. Newspapers quoted farmers who said the workers were efficient and appeared happy. Here Urbana Sauceda Avila shows his passport. Over the next decades, Mexicans who had come to pick cotton, tomatoes, string beans, and fruit settled in the town, building close family and community ties and creating businesses like Rosarita's Restaurant. After Portuguese American contractor Al Santos returned from Vietnam in 1970, other college students snickered when he said he lived in Alviso. "My teacher said, 'Hey, I go there all the time—to Rosarita's.' " Santos adds, "Alviso was kind of unique. Kids were together in one class through the years; all races were friends. (Courtesy *San Jose News*.)

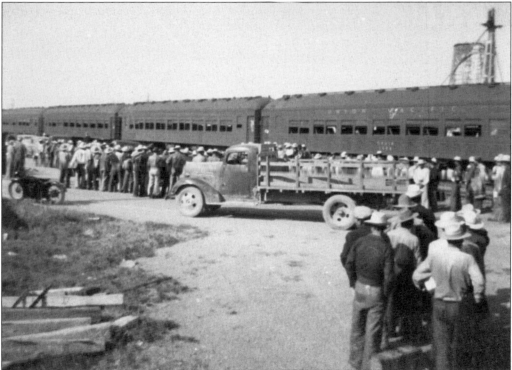

TRAIN BRINGS BRACEROS TO ALVISO. Hundreds of enthusiastic braceros arrived from Mexico to pick pears. Flatbed trucks transport them to farms and fields. (FH)

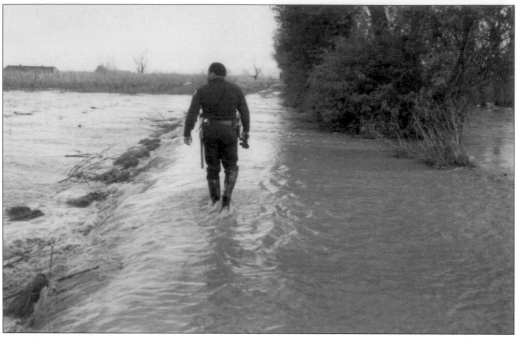

COYOTE CREEK FLOOD, 1983. Officer Cooper of the San Jose Police walks on Levee Road about a third of a mile north of Highway 237. In the background, apple trees are on the left and nectarines on the right. (Courtesy Bill Cilker.)

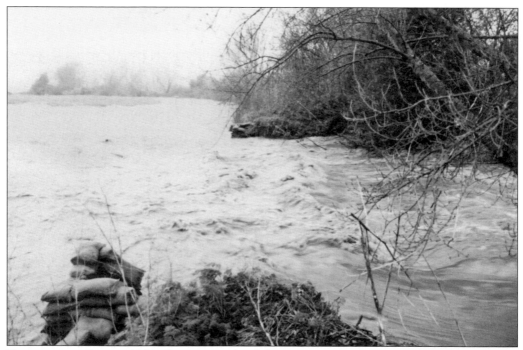

BREAK IN THE LEVEE, 1983. Continuous April showers proved to be too much for the north end of the Coyote Creek. (Courtesy Bill Cilker.)

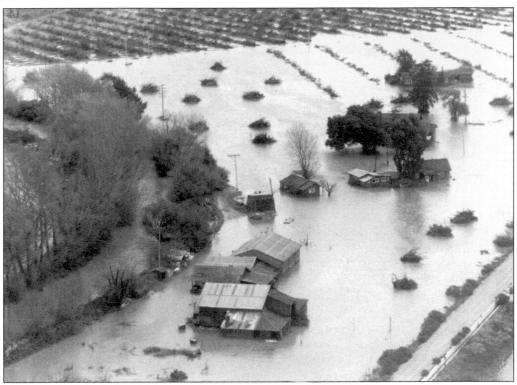

COYOTE CREEK FLOODS ALVISO, 1983. Steady March rain caused the Coyote Creek to overrun its banks near Milpitas, flooding McCarthy's pear orchard. (Courtesy Bill Cilker.)

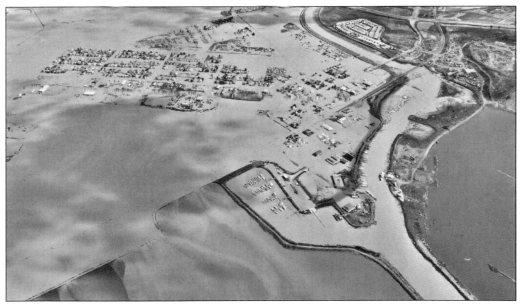

NORTH END FLOODS, 1983. The Guadalupe River passes by the Alviso Marina on the lower right. Coyote Creek, three miles to the left, engulfs the town in eight feet of water. (DENWR)

CHIEF YNIGO, RANCHO POSOLMI. In 1844, Governor Micheltorena granted this rancho to Chief Ynigo and his tribe, who inhabited the land now occupied by Moffett Field. This ranch was occasionally referred to as Pozitas de las Animas, locally translated as "Little Well of the Souls." In 1881, it was "patented" to a Scotsman named Robert Walkinshaw. In 1847, he came to California to take charge of the New Almaden Mine for Barron, Forbes, and Company, a British trading firm from Tepic, Mexico. (Courtesy Jim Arbuckle.)

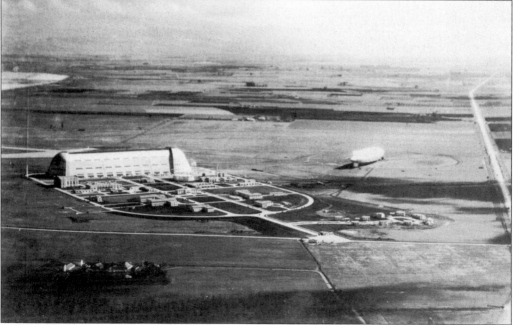

MOFFETT FIELD, 1935. Across the water from Alviso, Sunnyvale Air Station housed huge rigid blimps. When the *Akron* fell from the sky, 73 out of 75 people perished, including Admiral Moffett. Three crewmembers were rescued. In 1942, the air station was recommissioned as Naval Air Station Moffett Field. (Courtesy Moffett Field Museum.)

Seven

PEOPLE AND HAUNTS

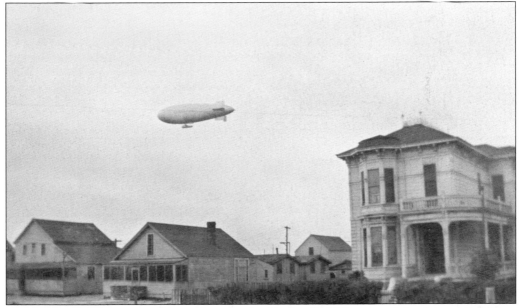

BLIMP OVER ALVISO, 1931. Blimps from nearby Moffett Field frequented the skies over Alviso. Alviso's unique ambiance drew a variety of characters over the years. It is hard to separate the personality from the haunt—Amelia Vahl, for example, will be forever associated with her restaurant. Alviso is a place with room for creative contradiction. It has drawn missionaries and gamblers, boat people and dignitaries, the religious and the bawdy, immigrant entrepreneurs and dispossessed idealists. Most were maverick do-it-yourselfers following their dreams. In or out of the mainstream, they were willing to persevere. Encarnacion Pinedo wrote the first Mexican cookbook, Thomas Foon Chew had to overcome prejudice, and the Portuguese Santos family rose from farmworkers to landholders. All grappled with challenges and sailed past barriers of race or gender, natural disasters, losses, burdens, and reversals of fortune. Colin Busby, principal of Basin Research Institute, says "Alviso is funky." It's a place for those who do not want to join urban society but instead live on their own terms. Though at times Alviso seems a ghost of its past high points, it is a panoply of rich history. From the mud-sunk cabins of Drawbridge to the James Lick Mansion, from the boats stuck in the tule grass to the new multicultural library, Alviso's people and haunts have quirky charm and spirit. (TL)

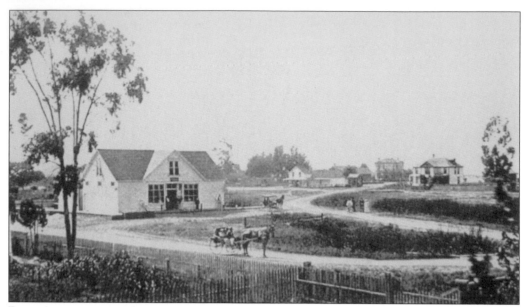

PORT ALVISO, 1895. This postcard looks northwest at the seaport town of Alviso. The diagonal Alviso-Milpitas Road (today's First Street) turns right toward "Steamboat Slough." In the foreground on Catherine Street, horses pull buggies past the Ortman Store (left), the Trevey store (center) and the LaMontague Boardinghouse. Even though the New Chicago scheme had taken town funds, Alviso was a terminal for stage, steamboat, and train. Passengers took the South Pacific Coast Railroad to Santa Cruz. (Courtesy History San Jose.)

ORTMAN'S STORE, 1931. Even at the height of the Great Depression, the store served as a kind of parlor for folks entering or leaving Alviso. Here locals come out in the sunshine. Pictured, from left to right, are (first row) Mr. Whitmire, "Ap" Laine, Mr. Keener, and Manuel Ramiez; (second row) Bill Ortman, Charles Ortman, unidentified, and Len Starks. (TL)

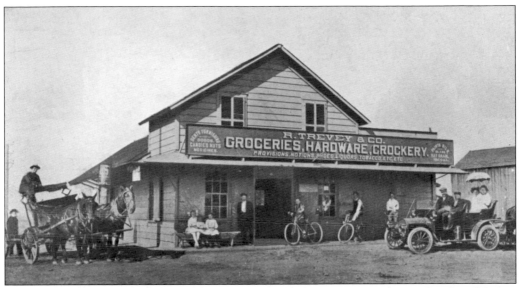

ROBERT TREVEY'S COMPANY STORE. The sign reads "Groceries, Hardware, Crockery." It was often said, "If you couldn't find it in San Jose you could always find it at the Trevey store." This photograph shows four types of transportation. (FH)

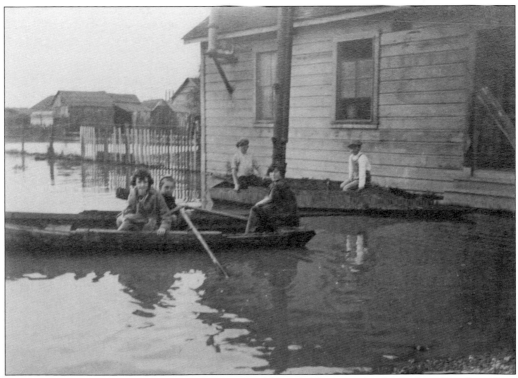

CHILDREN ROWING HOME. The Perkins and Dibbles children row by the Perkins Butcher Shop on Catherine Street crossed by El Dorado (right). The Perkins family contributed to Alviso's heritage over the decades, including giving the town a mayor, postmaster, and merchant in Stanley Perkins. Note the duck boat in the rear. (FH)

TILDEN HOUSE ON ELIZABETH STREET, 1890. Susan Ortley Tilden built the finest residence in Alviso, a large two-story house with well-appointed grounds. The pillared Victorian stands as evidence of the town's prosperous days. The widow's—or captain's—walk on top of the house was a railed observation area on homes near the sea, giving the observer a clear view of incoming vessels. Pictured on the steps, Minerva Tilden Laine came from a line of strong women; her mother, Susan Ortley, was brought around Cape Horn in the winter of 1852 by her widowed mother who perished in the voyage. Twenty-year-old Susan raised her sister, married, and was twice widowed. To support her daughters, the undaunted widow built a general store dealing in liquor, tobacco, drugs, boots, shoes, clothing, and hardware, as well as groceries. Minerva Tilden married "Ap" Laine. (TL)

TILDEN LAINE STORE. From 1865 to 1912, Susan Ortley Tilden and her daughter Minerva ran the Tilden Store. According to one of Minerva's grandsons, former mayor Tom Laine, it was built because South Pacific Railroad planned to lay track into Alviso. During the lawless 1930s, Minerva rented it out; the store was a saloon, Filipino dancehall and the site of a secret Chinese lottery. (TL)

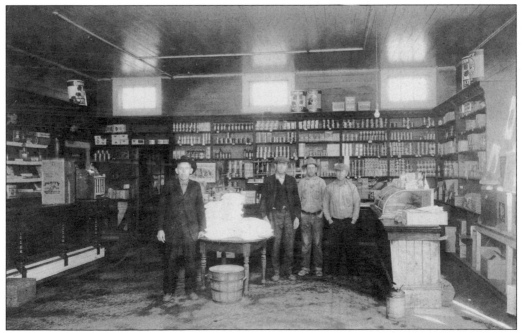

INSIDE AN ALVISO STORE, C. 1875. Old Mr. Ortman, Bill Ortman, unidentified, and Fred Huxham IV stand amid conveniences. Old Dutch Cleaner, salted wafers, Folgers Coffee, Carnation Wheat Flakes, Albers Flapjack Flour, and chewing tobacco are displayed on the shelves. Electric light bulbs and slot machines were favorite additions. Little Fred remembers old Mr. Ortman telling stories around the potbellied stove. (RB)

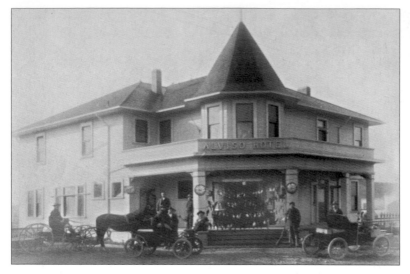

ALVISO HOTEL, 1905. Regulars include William Gallagher (in the buggy), Joseph Pipes (standing, with little Joe Pipes), James Davies, William Clampitt, hotel proprietor John Maine (standing), Henry Richard (sitting), William Ortley, and Mr. Tambini. (Courtesy George Treveno.)

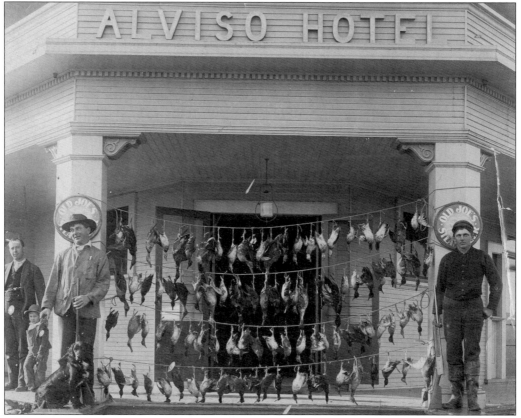

DUCK HUNTERS' DISPLAY, 1903. Duck was plentiful in the Alviso estuary. Joe Pipes, little Joe Pipes, Henry Richards and 28-year-old Bill Ortley display "one day's limit." (FH)

BORDELLOS AND GAMBLING. Former mayor Tom Laine confirms it: Alviso had its shady side, peaking in the 1930s. Gambling and bordellos abounded. "It was a wide open town," says Laine. "At that time, so was much of the valley," adds Beverly Laine. "Out shopping, you could pull slot machines behind a curtain." This building was a Chinese cookhouse, later a gambling place; the upstairs (run by non-Chinese) was a bordello. After the war, around 1945," Laine says, "things got cleaned up." (RB)

STAIRWAY TO THE SHADY SIDE. Two outside stairways ran to a bordello located in today's Seafood Grotto—right across from the Laine house. Customers could also come in the front door, pass to the right of the desk, and go upstairs. Tom Laine remembers being at home when he was seven; his dad and pals were out back preparing for a fishing trip. Suddenly some men barged in and ran upstairs, where his mother and aunt lay sleeping, yelling, "Where are the gals?" His dad called the police, who ran after the men and shot in their direction. (Courtesy Lynn Rogers.)

Dancer Jumps Into Water But Lands in Deep Mud

Miss June England, 25, Alviso Filipino dance hall "hostess," whose escapades have gained her wide publicity, got only a bad surprise, a ruined gown and badly wrecked dignity instead of death from the waters of Alviso Slough in an attempted suicide leap, Deputy Sheriff John Fortado reported today.

Instead of sinking into oblivion under the gently-lapping waves, she found herself in the muddy ooze of the slough's bottom, for the tide was out and there wasn't any water—that is, no more water than was necessary to make the mud just light enough so she couldn't walk or swim.

The effect of landing in the mud, which had an effect such as it could have only upon a young woman dressed in her best finery, which she had anticipated would be her shroud, caused June to change her mind, and she started yelling for help, Deputy Sheriff Fortado reported.

Two unidentified boatmen heard her cries, went to investigate, threw her a rope and a couple of boards and dragged the bedraggled dancer from the mud to the safety of the dock, the deputy said.

She thanked the men and left in search of a shower and a cleaning shop, the officer reported.

June England, hostess at an Alviso Filipino dance hall, who officers report dived in Alviso Slough in a suicide attempt — but the slough contained mud instead of water.

LOCAL GAL LANDS IN MUD. At a time when women were divided into good or bad, this young taxi dance hostess often found her name in the papers. First it was unseemly for white women to dance with Filipino men, then it was decided the women could take their money. One night, a couple of lovelorn young guys followed June England home on Highway 101. Later her own sweetheart jilted her and left her with child. She jumped into the slough, but the mud saved her life. (Courtesy Alviso Library.)

FAITH-BASED MINISTRY. The Jubilee Christian Center stands on the Alviso border and serves Silicon Valley souls seeking a full gospel, Spirit-filled experience in English, Spanish, Vietnamese, and now Filipino. Jubilee has grown to 13,000 members, including Hispanic Alviso youth, and has celebrated its first 25 years of ministry. Pastor Dick Bernal (left) wrote about coming of age as a carousing young farmworker until his wife, Carla, helped turn his life around. (RB)

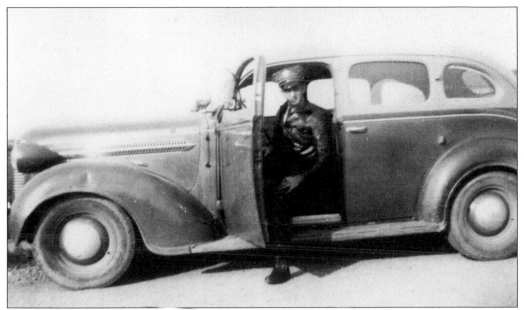

POLICE CHIEF TONY SANTOS. The Portugese Santos family came from Hawaii 90 years ago and moved from farm labor and hauling to own much of Alviso. Fiery Tony Santos was also mayor and sold migrant workers plots for $5 to get them back on the tax rolls. He favored business through consolidation but became bitter over "broken promises." Son Dick Santos was fire captain and now water district board member; son "Al" is a contractor. (Courtesy Dick Santos.)

DOG RACES IN ALVISO. In 1932, San Jose realtor Arthur Gray built this greyhound racetrack, later used for midget hardtop auto races. Former garage man Truman Lester reported, "no raids or shutdowns until the plant was sold to the Chinese." They fixed up the space underneath the Speedway grandstand; $10,000 turned it into an "elaborate gambling room." Before its wood was sold for lumber and the land for agriculture, swallows lived on the roof. Racing continued at Doc Becker's Alviso Speedway on State Street. The oval dirt track attracted hard-top jalopy racers like Yuba City Slim from the late 1940s to the mid-1960s. Some say Pachuco lowriders and bikers hung out through the 1970s. (Courtesy Alviso Library.)

VOTE FOR

WILLIS A. LAINE
INCUMBENT

Candidate For

CITY CLERK
City of Alviso

Prompt, Courteous Service to All Election May 6, 1935

NINETY YEARS IN ALVISO. In 2000, Willis Lane passed away while living in his grandmother Tilden's home. He had served as clerk, mayor, worked for the sewage plant, and sold bait for fishing striped bass and sturgeon. He talked about the old days of Alviso's independence from the "high-tech mania of San Jose." His wife, Yolanda, served as treasurer, son Tom as mayor, and Tom's wife, Beverly, as the second woman yacht club commodore. (Courtesy *San Jose Mercury News*.)

DISTINGUISHED ALVISO VETERANS. Fred Mizota served his country. He and his brother enlisted even though his family and others like the Nitaharas had been taken from their strawberry ranches to Japanese internment camps. Other heroic veterans included David Ameilia, Edwin Amelia, Raymond Avila, James Bacigalupi, Jesse Brite, Herman Canha, Ernest Carabal, Henry Carlton, Ralph Clampitt, William Clampitt, Edward Collins, Alfred Davis, Joseph Santos, John Posada, Manuel George, Ben Gonzales, Danny Gonzales, Louis Gonzales, Charles Mizota, Chris Ramirez, Arthur Silva, Tom Sakamoto, James Santos, Joseph Sutter Jr., William Zanker, Harry Cody, and Fred Gonzales. (FH)

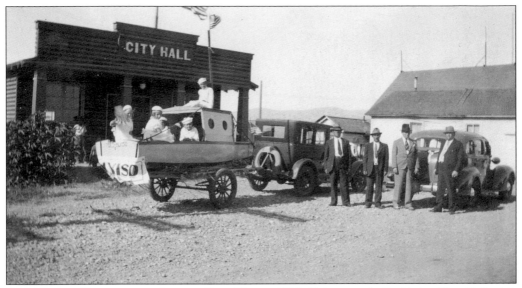

DEDICATION CEREMONIES, ALVISO CITY HALL, 1935. Volunteers built Alviso City Hall with donated land and materials—as they built the firehouse after the war. Over the years, it served as community center, boat dock headquarters, economic opportunity center, library, community policing center, and post office. (Other post office locations include Taylor and Gold Streets, behind Trevey house, in Perkins/Laine Store, on Taylor by the hotel, in Norma's Bait Shop, and today, north of the health clinic.) (TL)

THE ALVISO ROTARY FLAG. Chartered on May 21, 1990, with Pres. Melvin Guererra, today's Rotary is the heart of Alviso's civic activities. Led by Pres. Dale Warner, the group meets for lunch at Vahl's Restaurant every Wednesday at noon. They worked with public and private grants to build the new post office, plant numerous trees and vegetation, and lay paving. They donate books to the Alviso Library and to George Mayne Elementary School teachers. Their Steps to Success program gives shoes and socks to students. The Rotary supports the Santa Comes to Alviso program. On March 25, 2006, the Rotary helped the Mountain Charlie chapter of E. Clampus Vitus install a historical plaque at the Alviso Marina. (Courtesy Joan Hoxie.)

115

ALVISO'S SECOND FIRE TRUCK, 1946. Ralph Clampitt, Marie Clampitt, and Alfred Davis stand by the truck at the Montagne Residence on Catherine Street. "The first truck was an old Model T that just didn't work most of the time," Fred Huxham recalls. "Our new truck built by Headberg Motors in San Jose was a real fire truck! It was a volunteer operation depending upon who got there first." (FH)

POLICE CHIEF CHEW. Arnold "Pat" Chew worked the rodeo circuit for 30 years, from Calgary, Canada, to Madison Square Garden in New York and the Cow Palace in San Francisco. He kept a dairy farm on the old Beryessa place in Alviso near First Street until the late 1940s. Tom Laine says, "There were 10 or 12 flood gates on Pat's property. When fresh river water came flooding over by way of the Nitahara's strawberry ranch onto his place, he opened the gates for the town and sent the water into the bay. That's what Alviso needs now, to get the tidal flow back for habitats and fisheries." In 1953, Chew was elected as Alviso's last police chief, at that time its only officer. Until he got deputies later, he walked the foggy streets alone and passed his boyhood haunts. Born in Alviso in 1904 to longtime residents Judge Benjamin and Minnie Chew, he raised his children there and later worked as a bartender at Vahl's. (Courtesy Kathy Smith.)

ALVISO HEALTH CLINIC.
Established in 1972 by the
U.S. Department of Health,
Education, and Welfare,
the clinic was concerned
with "curing the sickness of
poverty," according to then
director Carlos Medina. Here
Dr. Coleman Vincent (right)
checks a senior citizen. From
its beginnings at the library to
Gold Street today, it has served
Alviso for 33 years. Staff like
Helen Luna and Lupe Lopez
support doctors treating the
underprivileged. (Courtesy
Alviso Library.)

Pushing Back Poverty

Alvisans have a doctor now, the first of the 20th century, and it's
because of the Economic Opportunity Commission that Dr. Coleman
Vinson (center) is making regular calls at the town's service center.
Here he checks a senior citizen. At left is EOC community develop-
ment specialist Jose Lopez. The city is in desperate need of a dentist.

ALVISO WOODCARVER. Charles Everett creates totems and animals with his chain saw. Everett's
Alviso yard is lively, with wooden owls, bears and eagles. He carved the mission cross replica,
and his pieces adorn the Branch Library, Great America, and other sites. He and his wife—a
retired high-tech officer—traveled the county distributing carving. "I have to do this," he says.
(Courtesy *San Jose Mercury News*.)

SUTTER'S PLACE. The Sutter place sheltered Swiss immigrants to Alviso, offering a way station for newcomers from the old country. "Never hurt anyone on the inside or the outside," was the family saying. In 1929, they bought the Panama Bar on First Street for $6,000. Joe Sutter tended bar on a sawdust floor. In the 1980s, they held the last San Jose gambling license and drew players from Oakland; Bay 101 assumed the license in 1994. (Courtesy Charlene Sutter-Arvizu.)

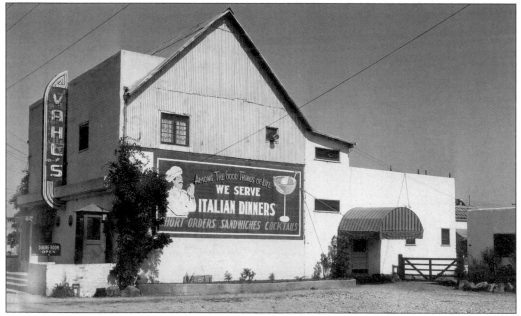

VAHL'S RESTAURANT. Amelia Vahl's personality and accomplishments reflect Alviso. Her "floodwater dinner house" boasted photographs of diners bobbing through the restaurant or "anchored outside in skiffs." Born Amelia Rebozzi in Los Banos to Swiss dairy farmers, she came up strong and edgy, managed the Costa Hotel (later the Cloverleaf Bar) in San Jose in 1929. Serviceman Eric became her second husband in 1941. They opened Vahl's. He ran the bar; she greeted diners by name for 68 years. (Courtesy Paul Rebozzi.)

118

MATRIARCH AND CREW, 2004. Working to the end, Amelia Vahl was surrounded by support. When she passed two months later, the jukebox still played 45s. She was full of curiosity and energy, a mix of toughness and charm —a no-nonsense boss who sent soup to sick employees and peaches to Carmelite nuns the last years of her life. Supervisor Pete McHugh eulogized, "We have lost part of our history. Amelia was a wonderful, valiant, feisty woman." (RB)

THE PARROTS KNOW. "Vahl" cared for Andy's Pet Shop parrots when the owners went on vacation. The birds got around; Vahl put them in the bar, and they heard things. Perched in a gilded cage, "Jewel" repeated colorful expressions uttered by patrons. What did the parrots know? Did they start rumors about 1930s entertainment upstairs around town? What about the politicians' secrets Vahl is said to have taken to her grave—only the parrots know for sure. (RB)

CAR TROUBLE, 1929. Pictured, from left to right, Srs. Eugenia Shea, de Chantal Cooney, and Benedicta Flannery are stalled on the way to Alviso. (Sr. Seraphim Kyip took the picture.) "Sure enough there was not a breath of air in it. Two of us walked back to the nearest garage for help and were glad to go home after repairs were made, and that was the end of our 'first day'." (Courtesy Sisters of Holy Family.)

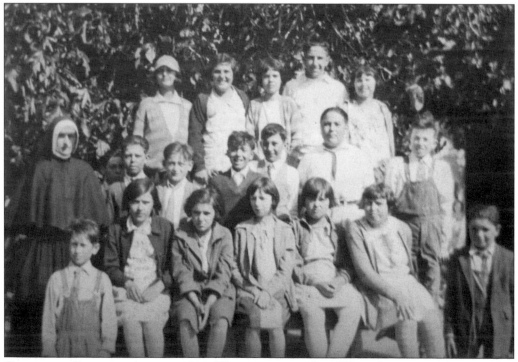

CATECHISM CLASS AT ALVISO, 1929. The sisters came from Warm Springs to Alviso to offer spiritual instruction. Children met in sites like the Trevey store, and when there was a flood and no heat, in the Huxham barn. (Courtesy Sisters of Holy Family.)

EDNA CLINTON RIDLEY. Born in 1873 to a teacher and a San Jose builder, Edna Clinton tested to skip high school and entered San Jose Normal School (later San Jose State). Graduated in 1893, she taught for a couple of years and married gold miner Lee Ridley, who died in 1906. She raised five daughters, including one with special needs. When electricity came to the valley, she watched the workman wire her mother-in-law's big house and decided she could do it herself. She strung wire through the family's cherry orchard and pulled it through the cheesecloth ceiling covered with wallpaper. She dropped a cord into each of the four rooms of her small house and hung a bulb to bring in the light. (Courtesy Nadine McIntyre.)

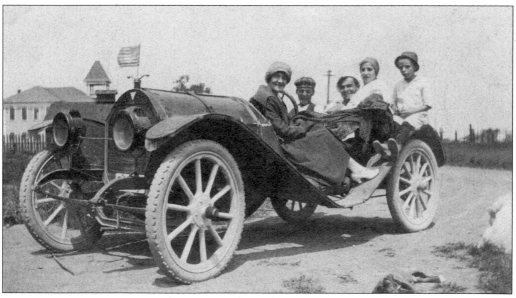

ALVISO ROADSTER, 1917. Eighteen-year-old Fred Huxham IV and his sister Juiletta (second from right) take friends on a spin through the Alviso streets in their 1917 roadster. That day, the wind blew south, past the Alviso schoolhouse (at left), built 17 years before. Fred later served as mayor. (FH)

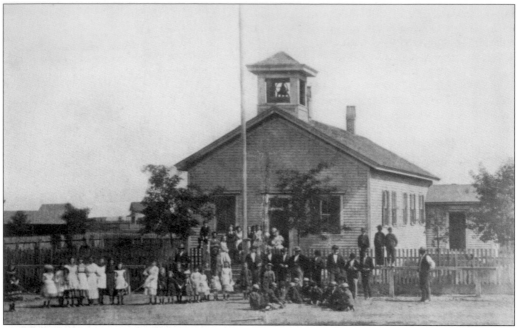

ALVISO'S FIRST SCHOOLHOUSE, C. 1860. This school served farmers' children in the northern San Jose area, including Rancho Milpitas. Bank of Italy (later Bank of America) founder Amando Peter Giannini attended elementary school here. (Courtesy History San Jose.)

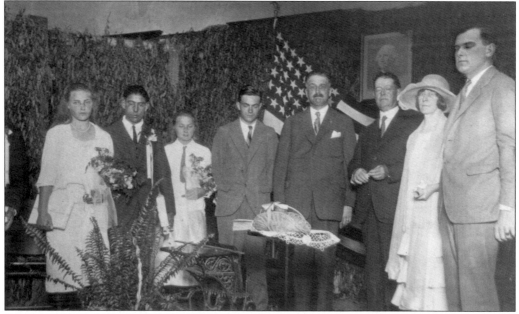

GIANNINI RETURNS TO ALVISO, 1925. A. P. Giannini grew up on an Alviso farm. His father was murdered in a dispute over $2. He founded a bank in which simple, hardworking people could open small accounts. Alviso graduates include, from left to right, Jimmie Hiratsuka, Frieda Baker, Lloyd Cesena, and Dorothea Baker. Officiating are Principal Paul Diaz, A. P. Giannini (who gave the diplomas), school official George Gallagher, unidentified, and speaker John Burnett. (Courtesy History San Jose.)

JAPANESE STUDENT, C. 1915. Her school stands in the distance. After Alviso Grammar School, Japanese students attended their own school in the afternoon. Japanese teachers came by ship and rail to teach traditional arts and sciences, and impart values like respect and reverence for teachers, elders, and grandparents. Fred Huxham remembers that girls like this student excelled in grammar school and later at Santa Clara High School, which served Alviso. Dick Santos remembers wishing he could take martial arts. (FH)

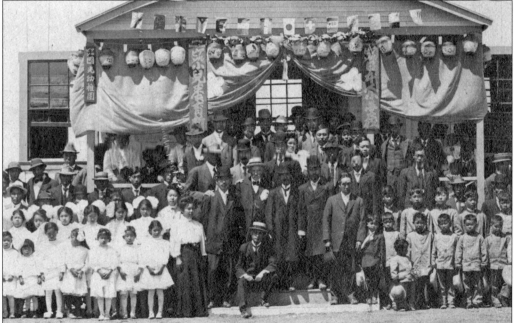

ALVISO'S JAPANESE SCHOOL. Located on Taylor Street between Liberty and Michigan, this was one of Alviso's Japanese schools. The Masakichi family of Campbell donated this photograph, taken July 21, 1910, to the Alviso Library. Twelve-year-old Masakichi Takata is identified on the right. (Courtesy Alviso Library.)

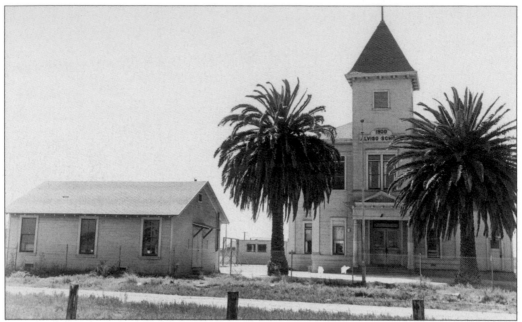

ALVISO SCHOOL. Built in 1900, this classic schoolhouse served Alviso students until George Mayne Elementary School opened in 1956. It was used by city hall and other groups until the 1970s. (Courtesy Alviso Library.)

ALVISO CLASS, 1938. Pictured, from left to right, are (first row) Herman Canha, Leroy Kawashima, unidentified, and Louis Gonzales; (second row) unidentified, Stella Nitahara, Marie Ramirez, Esther Gonzales, unidentified, Asaye Mizota, Jane Kanemoto, ? Weyamura, and teacher Paul Diaz; (third row) Susumi Weyamura, Hakaru Nitahara, Al Davis, Manuel George, unidentified, Billy Zanker, and Fred Huxham. (FH)

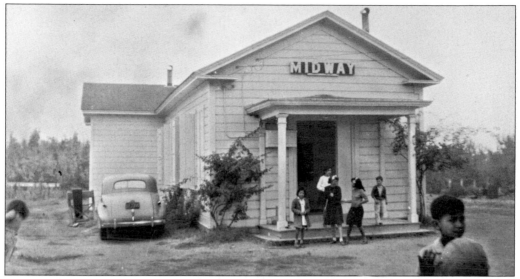

MIDWAY SCHOOL. Edna Ridley went back to teaching in the 1940s and taught 36 years in the Alviso area —at Midway School until it burned, at Alviso School in her seventies. This "remarkable little lady" (four feet, 10 inches tall) was dedicated to all her students, including Japanese and Slovakian farmworkers' children. She was Midway's teacher, principal, janitor, and its entire school board. (Courtesy Nadine McIntyre.)

MIDWAY CLASS, 1939. The year one boy graduated alone, Ridley still put on a play, composed music and verse, and invited speakers. With a bit of Ohlone ancestry, she once dreamed that trees could fall on the schoolhouse. She warned parents and students. When huge eucalyptus trees crashed onto Midway school, all were saved. She roofed her house in her nineties and was honored by college and media. She wrote poems and music until she passed easily from this world. She looked on the bright side. (Courtesy Nadine McIntyre.)

HISTORIC BRICK SEWER LINE. In the 1920s, San Jose built a sewer to the Guadalupe River. Waste flowed by gravity down the brick out-fall tunnel, three miles north through Alviso to the bay. Locals remember waste combined with salt water and fertilizers as "outrageous." Recently retired from service, this was the first pipe that emptied into Artesian Slough. "Phew!" These bricks had seen it all. Something had to be done. (Courtesy Environmental Service Department.)

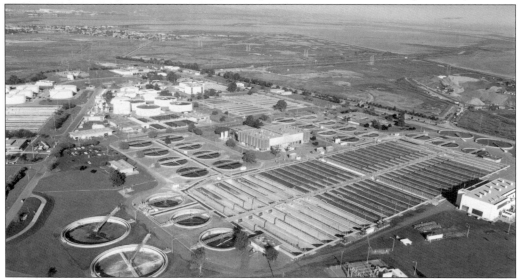

ENVIRONMENTAL SERVICES. In 1965, San Jose built the first raw sewage plant on Zanker Road. It offered primary treatment for 36 million gallons of wastewater daily—a step forward from the smelly days of yore. Today's expanded plant serves 1.5 million, spans 300 square miles, and treats over 167 million gallons of wastewater daily using a six-step process. Water discharged into the bay may disrupt its fragile ecosystem. Residents and businesses are being educated to conserve usage. (DENWR)

SEN. DON EDWARDS. In 1968, grassroots groups inspired Sen. Don Edwards to introduce bills protecting remaining wildlife habitats along the San Francisco Bay. Since the 1970s, the South Bay wetlands on the Alviso shore have become part of the largest urban wildlife refuge in the United States. They are home to thousands of creatures, including two endangered species. In the microcosm of Alviso is California's pattern with a prophetic twist. What was lost may be reclaimed. The lost port of Alviso has become a sanctuary out of time where humility, the gentle mixing of ethnicities, and the sound of marsh birds refresh the spirit. (DENWR)

CALIFORNIA CLAPPER RAIL. By 1915, these birds had been hunted to near extinction. Today they can be found along the bay. Males and females look almost identical— between 1 and 1.5 feet long, brown with white tail feathers and bright orange legs and beaks. Protected by wetland mud and water, they lay eggs on shallow ground nests of dead marsh grasses. Clappers scoop worms, mussels, fish and crab from the mud during low tide. (Courtesy Alvin Dockter.)

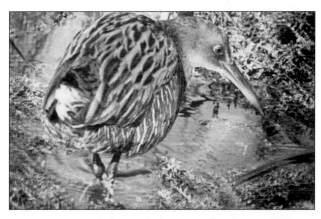

SALT MARSH HARVEST MOUSE. Pickleweed is the primary habitat for this tiny marsh creature; it uses it for food and shelter. Sold in farmer's markets, pickleweed is also an edible wetland treat. It was used by the Ohlones to spice and flavor their foods. Both the Salt Marsh Harvest Mouse and the California Clapper Rail bird were included in the Tidal Marsh Ecosystem Recovery Plan set forth in the Federal Endangered Species register of 1970. (RB)

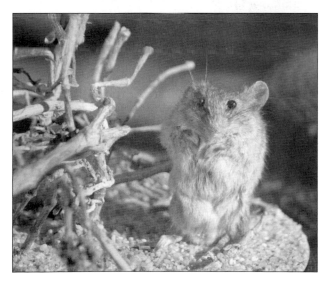

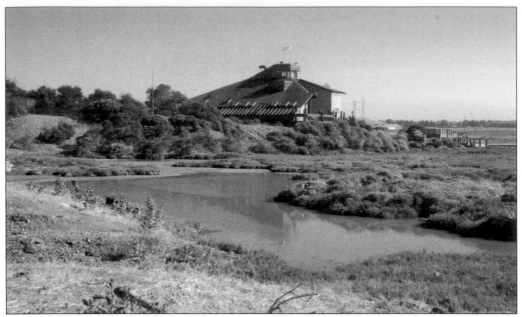

DON EDWARDS NATIONAL WILDLIFE REFUGE. A total of $9 million was authorized to acquire 23,000 acres for the refuge. In 1979, the Environmental Education Center in Alviso was built and staffed. Established to benefit wildlife and people, the refuge maintains habitats and protects endangered species and migratory birds. It provides opportunities for wildlife recreation and nature study. (RB)

ALVISO MARINA AND PARK. In the 1890s, the New Chicago development was envisioned here as a great manufacturing center. Today this same land has been restored as a non-tidal salt marsh, aptly named New Chicago Marsh. According to Ohlone tribal chairperson Ann Marie Sayers, Native American wisdom has at last returned in Alviso. Life has come full circle. (RB)